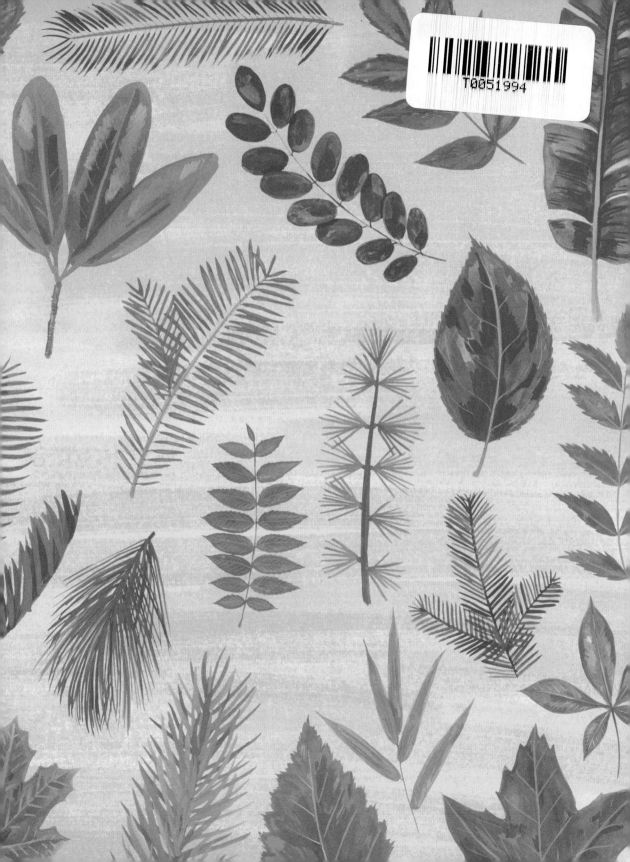

TREES

TREES

an illustrated celebration

Kelsey Oseid

TEN SPEED PRESS
California | New York

CONTENTS

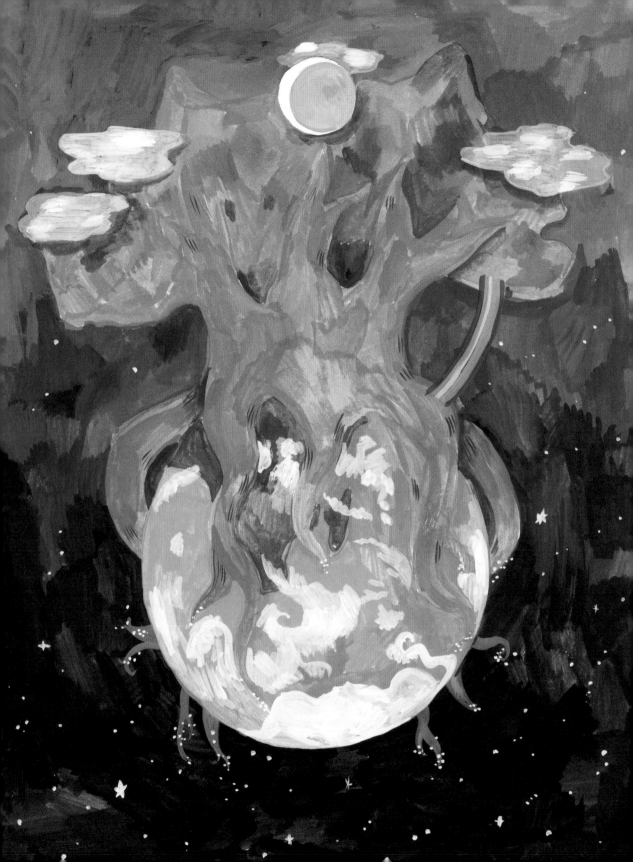

INTRODUCTION

We originated in the trees—our ancient ancestors lived arboreally, and we developed the hands and limbs we have today by swinging from branch to branch. Early humans continued the relationship with trees, using them not just for food, shelter, and fuel, but also as sacred final resting sites, burying their dead within hollowed-out tree trunks. Countless cultures have a concept of a mythical world tree, a gigantic tree that connects the terrestrial world with spiritual realms. World trees are depicted as any number of species, depending on the geographic source of a specific myth, and are often shown with their branches spreading up into a divine cosmos and their roots reaching down into an underworld.

In modern times and urban settings, it's easy to take trees for granted or even forget about them altogether. Many of us have never planted, pruned, or tended to a tree in any way. We can go all day without glimpsing so much as a single branch. And while much of our food and shelter still come from trees, we are often so removed from the harvest that we forget how much of our nourishment and other comforts originated among the branches.

While we've become distanced from trees in our daily lives, our scientific understanding of them is flourishing. Recently, scientists have studied the ways trees talk to each other through the transmission of invisible airborne chemicals that can trigger neighboring trees to ward off pests. Studies have shown how certain trees share nutrients through complex underground networks of roots and partnering fungi. The more arboreal mysteries that we untangle, the more we seem to discover. While it shocks mainstream culture to find that trees communicate, these discoveries hearken back to long-held Indigenous knowledge. Biologist Robin Wall Kimmerer of the Citizen Potawatomi Nation points to a legacy of collaboration between humans and trees in which it was understood that trees talked to each other.

With more and more of us becoming city dwellers, removed from wilderness altogether, how can we find communion with the trees? While many people may no longer live in and among the forests, trees are among the largest life forms we can meet in person. A direct relationship with trees may not be possible for everyone, but learning and celebrating the ways that we know trees to be important, amazing, and beautiful is a great place to start. This book is a celebration of the diversity of trees on Earth, their evolutionary history, their surprising and sometimes strange beauty, and the ways humans have understood and interacted with them since ancient times.

WHAT IS A TREE?

There's no taxonomic definition of a tree (which is surprising, isn't it?). Instead, trees are defined by form. The most common qualifiers include an elongated trunk that supports itself, woody growth, a substantial underground root system, leaves, and considerable size. Size that allows humans to walk underneath the plant is sometimes used to differentiate trees from shrubs, but this disqualifies many species that we readily accept as trees, like younger pines that may still carry low branches, or dwarf trees that will never grow large enough for us to walk under but are otherwise generally accepted as trees.

Humans have a tendency to catalog, name, and sort. Many of us see the world through patterns, and historically we've endeavored to discover (or possibly impose) order in the wildness of nature. Every species that we meet, we name and name again. What some call an eastern white pine is *Pinus strobus*, but it's also the Weymouth pine and the pumpkin pine. A linden tree is a *Tilia*, but also a basswood or a lime (but not the edible kind—those have their own list of names!).

Smaller broad leaf trees and conifers may be classified as shrubs instead of trees.

Broadleaf trees usually fit all the listed characteristics of a tree.

While conifers lack broad leaves, most are trees (their needles are actually a specialized type of leaf).

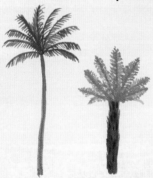

Palm trees and tree ferns are considered trees despite their lack of branching.

Saguaro cacti don't have leaves, but they are sometimes considered trees based on their size and shape.

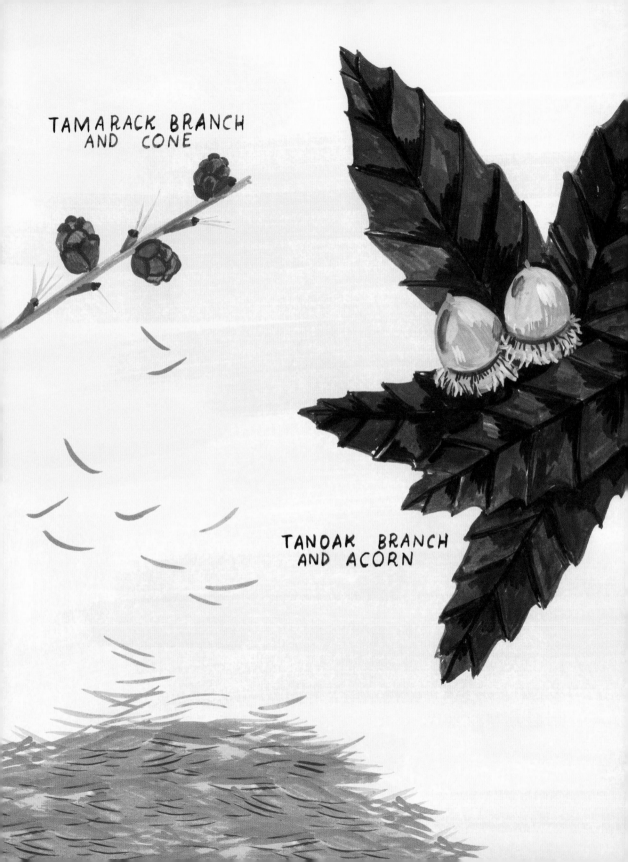

TAMARACK BRANCH
AND CONE

TANOAK BRANCH
AND ACORN

In biology, taxonomy attempts to locate species in relation to each other as a means of understanding and classifying them. This book will occasionally reference species that are or are not "closely related." These are relative terms, however, and apply only in the context of the narrower plant world. It is important to emphasize that all life is related. We all came from a common beginning; you can even find a common branch for humans and plants if you look back far enough on the tree of life.

A common starting place for the classification and identification of trees is whether they lose their leaves seasonally. Those that do are called deciduous, while those that do not are called evergreen. The term *deciduous* comes from the Latin *decidere*, meaning "fall down or off." (In fact, baby teeth are sometimes referred to as deciduous teeth.)

Trees can also be classified based on whether they are conifers—trees that bear cones. The categories of evergreen and coniferous often overlap, but not always. For instance, the tamarack (*Larix laricina*, also known as American larch) is a deciduous coniferous tree that loses its needlelike leaves each winter, while the tanoak (*Lithocarpus densiflorus*, also known as tanbark-oak) is an evergreen tree that does not lose it flat leaves annually.

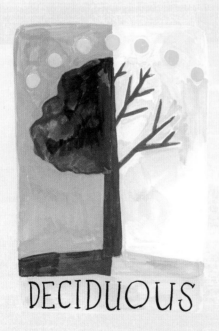

DECIDUOUS

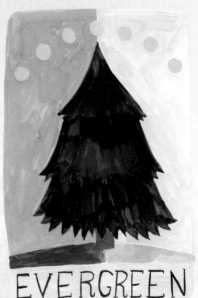

EVERGREEN

ANTHROPOMORPHIZING TREES

Perhaps one explanation for our deep connection with trees is their visual similarity to humans. The more you look for these parallels, the more you'll find them. We stand vertically, as do most trees. Our heads, like their crowns, sit atop a vertical body. Our limbs stretch outward from our "trunks," not unlike branches; blood flows through our veins much as sap flows through their trunks and branches. Trees that tilt from their usual upright alignment are called "drunken trees." In folklore, trees are described as coming to life and walking, and tales are told of people taking root and becoming trees, such as the dryads of Greek mythology.

TREES OF THE WORLD

Throughout this book, we'll explore some of the world's most beautiful, strange, and otherwise noteworthy trees. This isn't intended as an exhaustive catalog, however—there are more than 60,000 individual tree species around the globe! (But there are wonderful, comprehensive tree encyclopedias in print; I've recommended a few on page 146.) Instead of attempting anything all-inclusive—a job for a botanist—this collection is that of an artist and amateur naturalist. I've included some extraordinary examples of strange and curious trees, like the dragon blood tree (*Dracaena cinnabari*) on page 80, as well as more widely recognizable trees such as the oaks (genus *Quercus*) on page 108. I hope that you will learn more about some familiar varieties and meet some new ones.

Forest biomes are believed to cover one-third of the Earth's surface and contain about 80 percent of known terrestrial plant and animal species. Even biomes that are not strictly considered forest can be home to trees and can even be defined by them—for instance, the savanna biome is characterized by its mixture of grassland and scattered trees. And even the remote tundra up to the arctic tree line has its trees, though their growth is often stunted by the harsh climate. No trees grow on Antarctica, though—there you'll find only a few small plants and in just a couple of spots. But scientists have discovered fossil forests there, dating back hundreds of millions of years to when the world and its landmasses looked very different from the way they do today.

In general, trees are organized by their rough location on Earth, into three broad geographic categories: tropical, temperate, and boreal. (I've done the same in this book, and the sections on each category can be found on pages 73, 95, and 137, respectively.) There's considerable overlap between these categories, and many trees could be placed in more than one category; in such cases, I have placed them in the category of which they are most emblematic.

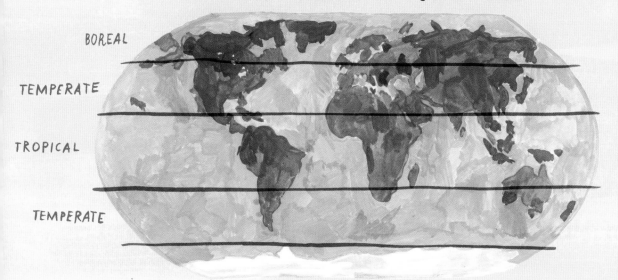

The Earth is divided into three major climate zones: tropical, temperate, and boreal. No trees grow on Antarctica.

BOREAL

TEMPERATE

TROPICAL

TEMPERATE

Tropical forests are found in the warmest parts of the planet, on and around the equator. They are the Earth's biodiversity champions. While estimated to cover only about 6 percent of the planet's surface, tropical rain forests (tropical forests without dry seasons) are home to 50 percent of its species. Temperate forests are found in areas north and south of the tropics; they have moderate climates and contain a mixture of broadleaf and coniferous trees. Some temperate forests receive so much precipitation that they are considered rain forests. The boreal forest, also called the snow forest or taiga, is found in the coldest and northernmost places on the planet. It forms a band of mostly coniferous forests at the highest latitudes; farther north, the climate is too harsh to support tree growth, and the forests recede into treeless tundra.

TREE PROTECTORS

Trees hold the earth together, both literally and figuratively. But as an important resource, they are exploited for profit, despite the often devastating consequences. Deforestation contributes to climate change, destruction of biodiversity, and other issues such as landslides, soil degradation, and disrupted water supply. It is often the world's poorest people who suffer the most when ecosystems are destroyed. In places where people's livelihood depends on the land and its trees, unsustainable destruction of wooded land can mean nothing more than a quick profit for the destroyers, made at the expense of future economic stability and well-being.

We have many activists and environmentalists to thank for the growing movement to protect forest ecosystems. The Chipko Movement in India in the 1970s and 1980s used nonviolent protest to physically stop forest clearing: activists were literal "tree huggers," protecting the trees with their bodies. Also in the 1970s, Kenyan activist Wangari Maathai created the Green Belt Movement to reforest land across Africa that had been cleared of its forests, resulting in local issues such as diminished firewood accessibility and poor nutrition, especially among poor rural families. She saw women's rights and democracy as intertwined with forest ecology and fought for them throughout her lifetime, ultimately becoming the first African woman to win the Nobel Peace Prize, in 2004.

In the late 1990s, in response to the clear-cutting of ancient redwood forests, an activist named Julia "Butterfly" Hill spent 738 days in the branches of Luna, a millennium-old redwood, 180 feet (55 m) above the ground. This loving act of protest raised awareness of the sacred and irreplaceable old-growth trees around the globe, though not without

blowback. After Hill descended, Luna was vandalized with a deep chainsaw slash at its base. Teams of tree workers, cheered on by tree huggers the world over, worked together to reinforce and stabilize the ancient redwood with brackets and cables, and, two decades on, Luna continues to watch over the forest—a symbol of hope for the planet's remaining ancient redwoods.

Canadian researcher Dr. Suzanne Simard has pioneered new research into the ways that trees exist not just as lone individuals in a forest but as components of complex interrelated and interconnected systems, with mycorrhizal networks threaded throughout. Her research shows how so-called mother trees—those hub trees most densely connected to the seedlings around them—provide for the younger trees and foster stability in forests. Her work challenges forestry practices that have long been accepted as standard, like clear-cutting and the planting of nondiverse stands of trees, which can make forests more susceptible to attack by pests or to firestorms exacerbated by development and climate change.

Mujeres Amazónicas ("Amazon women") is a twenty-first-century collective of Indigenous women from the Kichwa, Shuar, Achuar, Shiwiar, Sapara, and Waorani nations, all affected by oil extraction in their native territories in the Amazon. Mining and illegal logging have long threatened the Amazon, and women and Indigenous people are often at the frontlines of resistance on behalf of the world's largest rain forest. The women lead large-scale protest movements against deforestation by oil companies.

Scientists and activists, like these women, have identified the threat of deforestation and begged the world to address the ways that we use and manage forests—and they have also cultivated love and hope. Quick profits can be made by destroying the earth's bounty, but in the long run, the good of humanity and the good of the world's forests go hand in hand.

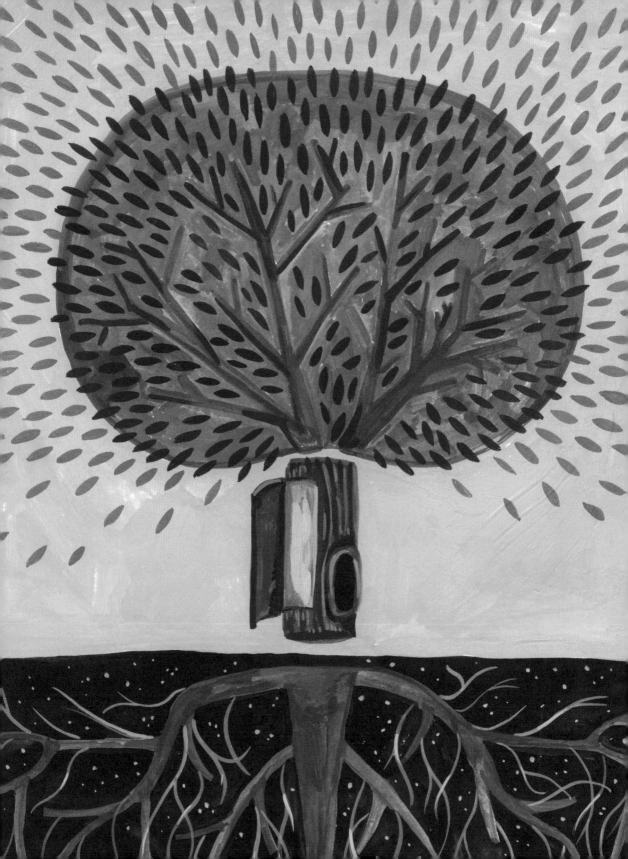

PARTS OF A TREE

LEAVES

Leaves are a great starting point for tree identification, not least because of how accessible they are. More often than not, we can touch them, hold them, and even pocket them to take home. They're also distinctive—many trees can be identified on leaf shape alone. But keep in mind that different leaves from the same tree can vary in appearance based on their placement and how much sunlight they receive. This variation can complicate identification, but as with all botanical classification on an amateur level, the puzzlement that we feel when trying to tell one species or variety from another can be part of the joyful mystery of interacting with plants in the first place.

When identifying a leaf, consider its shape, venation, margins, stalk, and more. Simple leaves have a single leaf on a single stem, while compound leaves are composed of multiple leaflets extending from a single stalk. Leaves can be lobed or unlobed, and the lobes themselves can be palmate (where the lobes radiate from a single point) or pinnate (where the lobes extend from points along the stem). In compound leaves, leaflets can also be palmately compound or pinnately compound—referring to the ways in which they extend from their shared stem.

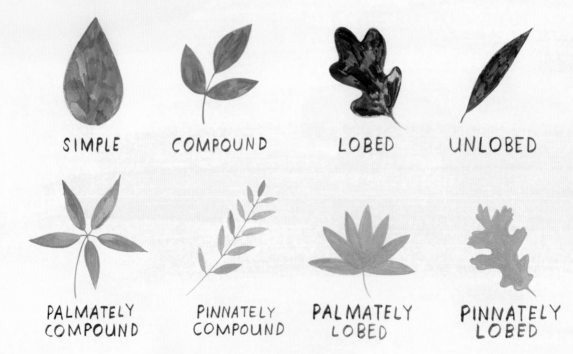

SIMPLE COMPOUND LOBED UNLOBED

PALMATELY
COMPOUND PINNATELY
COMPOUND PALMATELY
LOBED PINNATELY
LOBED

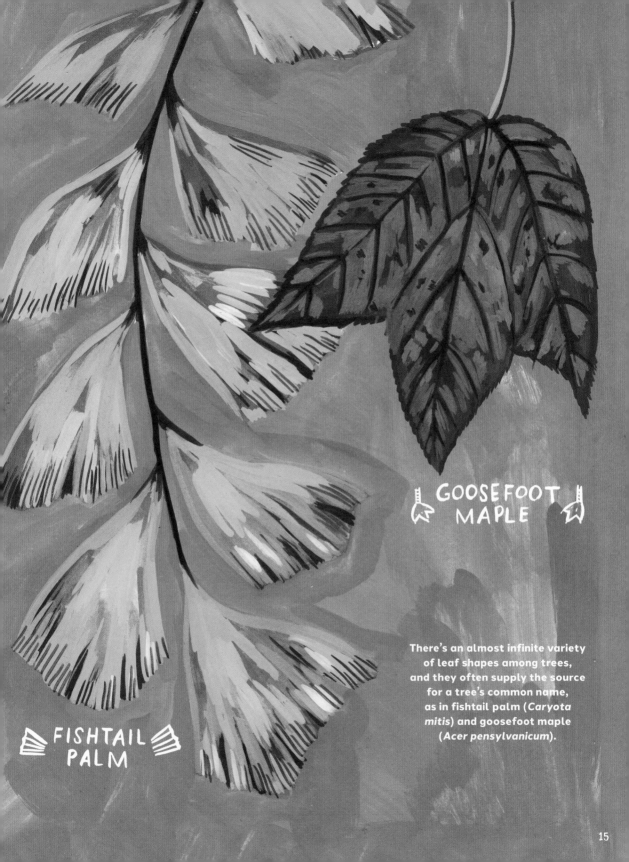

GOOSEFOOT MAPLE

FISHTAIL PALM

There's an almost infinite variety of leaf shapes among trees, and they often supply the source for a tree's common name, as in fishtail palm (*Caryota mitis*) and goosefoot maple (*Acer pensylvanicum*).

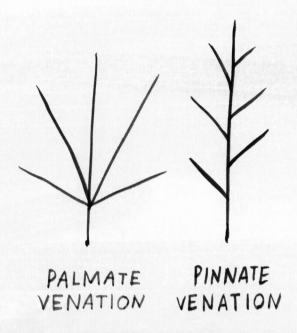

PALMATE
VENATION

PINNATE
VENATION

Venation patterning—the ways the veins are arranged on an individual leaf—is another helpful identifier. Veins can be palmate or pinnate, depending on whether their veins branch from a single point or multiple points along a primary vein. The outer edges of a leaf are called its margins. Common margin types include entire (smooth), toothed, and lobed, but the classifications and subclassifications for leaf margins are virtually endless and include ciliate (with an edge of tiny hairlike protrusions), spiny (lobes ending in sharp points), and more. The leaf stalk should be noted as well—this is the stalk where the leaf is attached to the rest of the tree. Its length, texture, and shape (for example, round versus flat) can help identify a tree when other distinguishing factors aren't available.

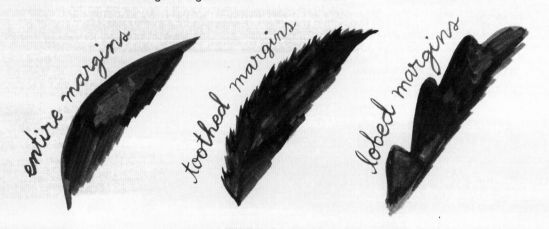

entire margins

toothed margins

lobed margins

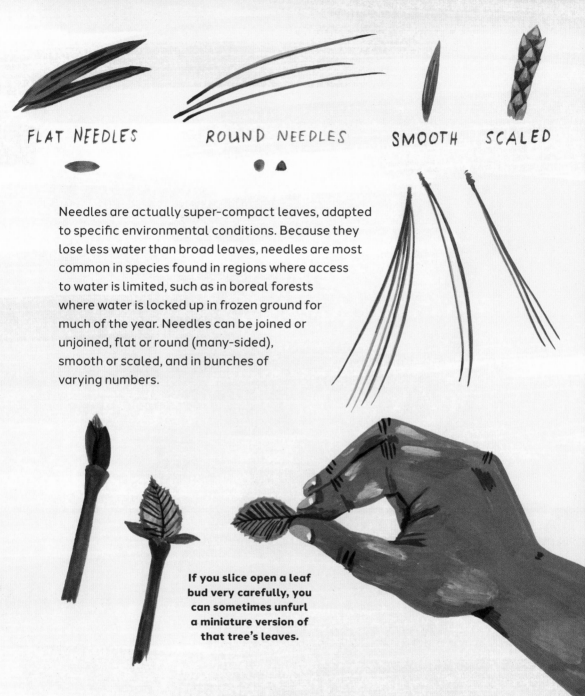

FLAT NEEDLES

ROUND NEEDLES

SMOOTH SCALED

Needles are actually super-compact leaves, adapted to specific environmental conditions. Because they lose less water than broad leaves, needles are most common in species found in regions where access to water is limited, such as in boreal forests where water is locked up in frozen ground for much of the year. Needles can be joined or unjoined, flat or round (many-sided), smooth or scaled, and in bunches of varying numbers.

If you slice open a leaf bud very carefully, you can sometimes unfurl a miniature version of that tree's leaves.

Many trees produce buds, which are protected growth packets containing the materials for future leaves, flowers, and other growth. When a tree is bare of foliage, buds can help in identification, especially when they are particularly distinctive.

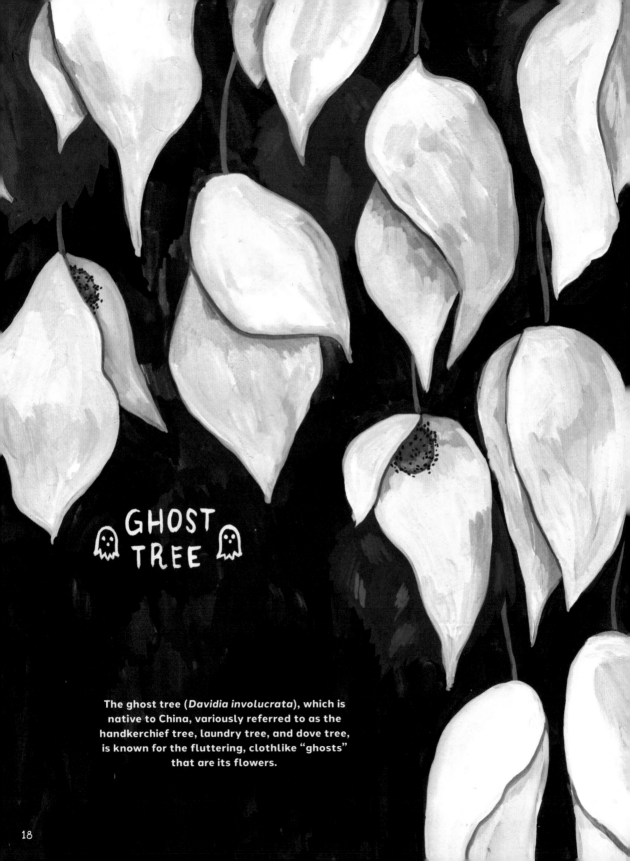

GHOST TREE

The ghost tree (*Davidia involucrata*), which is native to China, variously referred to as the handkerchief tree, laundry tree, and dove tree, is known for the fluttering, clothlike "ghosts" that are its flowers.

FLOWERS *and other adornments*

Most trees (except conifers) reproduce via flowers, whose purposes include sheltering the plant's reproductive parts and attracting pollinators. The flowers produced by trees are as varied in color and form as those in any florist's shop. While some trees are particularly known for their showy blossoms—like cherry trees—others such as maples hide beautiful blooms among their leaves.

north Japanese hill cherry
(*Prunus sargentii*)

cockspur coral tree
(*Erythrina crista-galli*)

blue jacaranda
(*Jacaranda mimosifolia*)

Japanese spicebush
(*Lindera obtusiloba*)

red maple
(*Acer rubrum*)

eastern redbud
(*Cercis canadensis*)

silk tree
(*Albizia julibrissin*)

tulip tree
(*Liriodendron tulipifera*)

Campbell's magnolia
(*Magnolia campbellii*)

POLLINATION

Pollination is the process by which pollen is transferred from the male part of a plant to the female part of the same or another plant of the same species. This must be done by a force outside of the tree itself—pollen doesn't move of its own accord—so a flowering tree relies on wind or animals to distribute its pollen. Hazel trees (genus *Corylus*) are some of the many trees that are wind-pollinated. Their pollen-bearing bodies—the male flowers—are called catkins (they get their name from the Dutch word for "kitten," for their resemblance to a fluffy tail; they are sometimes also called lambs' tails). The comparatively diminutive female flower sits much less conspicuously alongside the branch—a tiny starburst of pink tendrils emerging from a little scaly bud. When pollen—generously puffed out of the catkin and buffeted by wind—reaches this flower, the tree can begin the process of forming a hazelnut fruit. The African baobab (*Adansonia digitata*) is pollinated by fruit bats (also called flying foxes), which transmit pollen indirectly. When feeding on nectar, their fur becomes coated in pollen, which falls off as they fly from flower to flower and tree to tree. Figs (genus *Ficus*) are pollinated by fig wasps, who die inside the immature fruit after pollinating it. At one time, every fig on Earth would have had a tiny mummified or digested fig wasp inside of it (now, fig farmers hand-pollinate their trees).

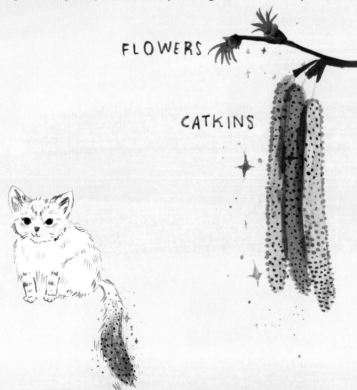

FLOWERS

CATKINS

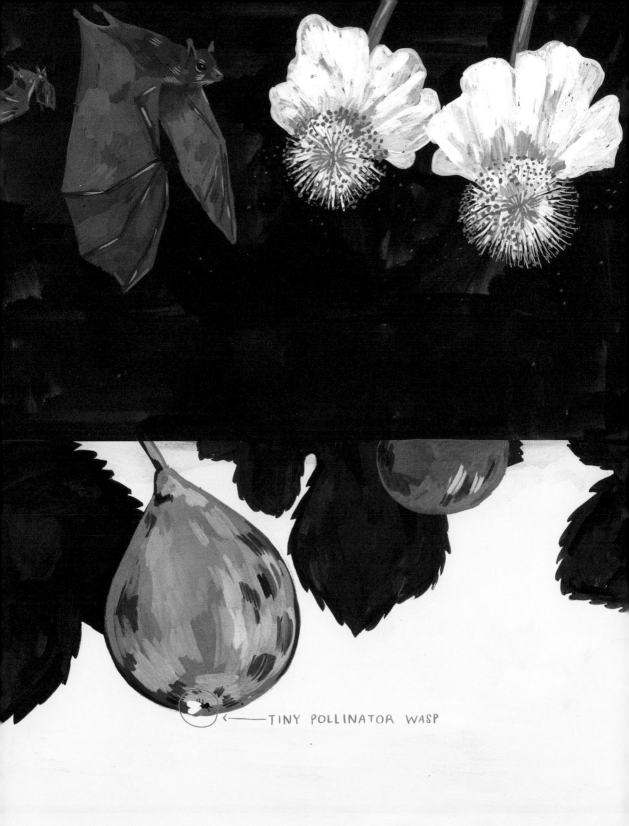

TINY POLLINATOR WASP

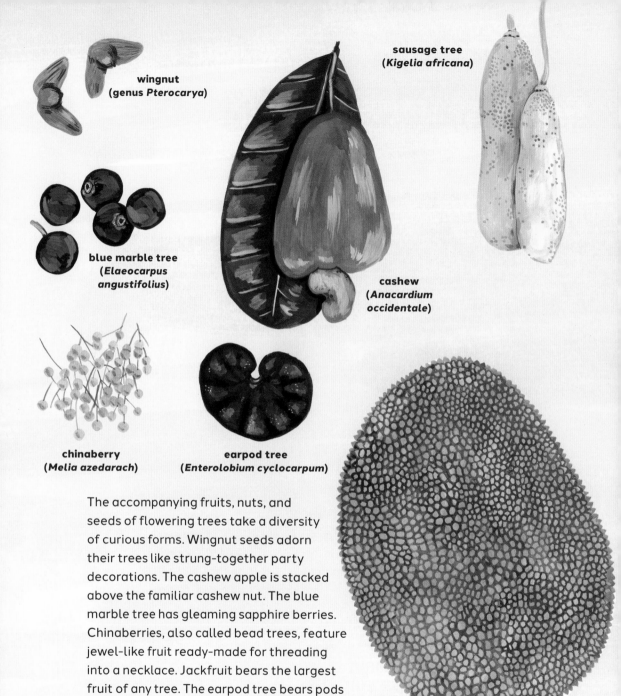

**wingnut
(genus *Pterocarya*)**

**sausage tree
(*Kigelia africana*)**

**blue marble tree
(*Elaeocarpus
angustifolius*)**

**cashew
(*Anacardium
occidentale*)**

**chinaberry
(*Melia azedarach*)**

**earpod tree
(*Enterolobium cyclocarpum*)**

The accompanying fruits, nuts, and seeds of flowering trees take a diversity of curious forms. Wingnut seeds adorn their trees like strung-together party decorations. The cashew apple is stacked above the familiar cashew nut. The blue marble tree has gleaming sapphire berries. Chinaberries, also called bead trees, feature jewel-like fruit ready-made for threading into a necklace. Jackfruit bears the largest fruit of any tree. The earpod tree bears pods that look very much like human ears, and the sausage tree is adorned with fruit that looks like sausages strung up in a butcher shop window.

**jackfruit
(*Artocarpus heterophyllus*)**

STRAWBERRY TREE

The strawberry tree (*Arbutus unedo*) is named for its round, textured fruits that, when fully ripe and red, look a lot like strawberries. The resemblance is purely superficial—while the fruit of the strawberry tree is edible, it's reportedly mealy and generally unenjoyable.

TRUNK & BARK

A tree's trunk supports its branches and leafy growth, but it also transports water up from the roots to the rest of the tree and food back down from the leaves, distributing energy and hydration to the entire organism (and beyond; see "Roots" on page 28). The center of the trunk is made of heartwood (dead wood), which accounts for the bulk of a tree trunk's mass and provides structure. This is surrounded by sapwood (living wood), which does the work of distributing water and minerals throughout the tree via the sugary sap. The sapwood is covered by an extremely thin and absolutely vital layer called the cambium, from which the tree adds its growth. On its inside, the cambium adds wood; on its outside, it adds bark. On top of that, the inner bark distributes food throughout the tree, and the outer bark serves as a protective layer, defending the tree from invaders (like beetles and other pests) and keeping undesired water out.

Dendrochronology, the study of history through the rings of trees, can reveal important data about climatic and other environmental changes over time. Trees put on different amounts of growth in years with different atmospheric conditions—for instance, they might add more growth in a year with more favorable temperatures or abundant rainfall. And because each growth ring can be correlated to a different year, a bored-out sample from a tree becomes a mini-timeline of the life of the tree. Scientists compare samples across trees and against other existing climatic data to learn more about the lives of trees and their surrounding environments.

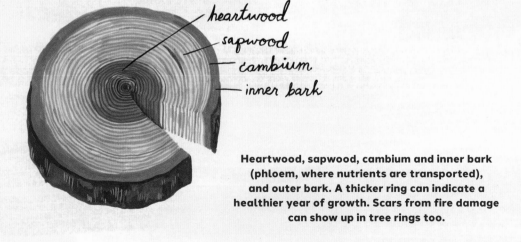

heartwood
sapwood
cambium
inner bark

Heartwood, sapwood, cambium and inner bark (phloem, where nutrients are transported), and outer bark. A thicker ring can indicate a healthier year of growth. Scars from fire damage can show up in tree rings too.

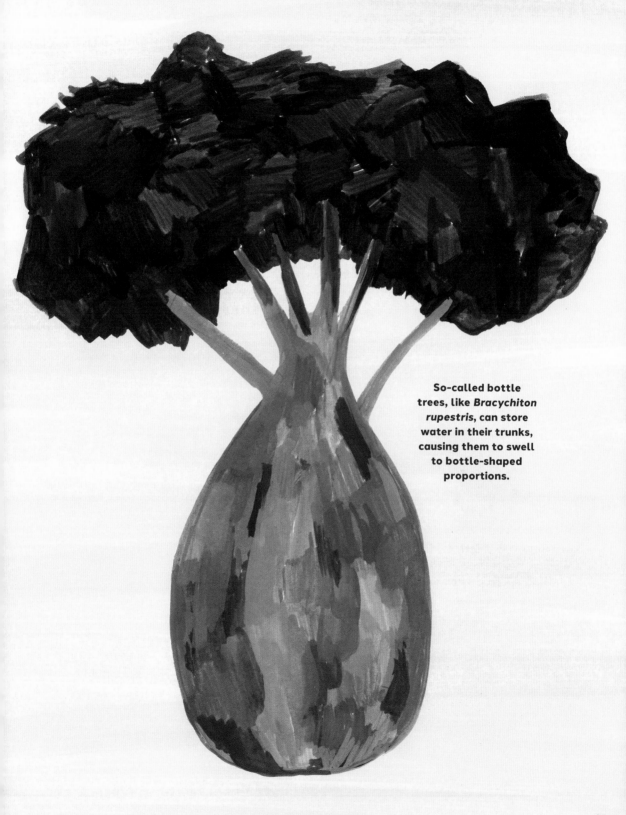

So-called bottle trees, like *Bracychiton rupestris*, can store water in their trunks, causing them to swell to bottle-shaped proportions.

Because bark, like the rest of the tree, is always growing, it generally becomes thicker and more distinctive with time. Bark also must expand to accommodate the increasing width of the trunk as the tree grows. It stretches around the growing tree, splitting and cracking when the girth becomes too much, and then fills in the gaps with more growth. This creates a diversity of visual identifiers among different species and ages of trees. (These are interesting to look at and can be helpful in identification, but are also potentially misleading, given their changeable nature over a tree's lifetime.) Lenticels, the pores in a tree's bark through which the tree breathes, also lend variation in appearance from species to species.

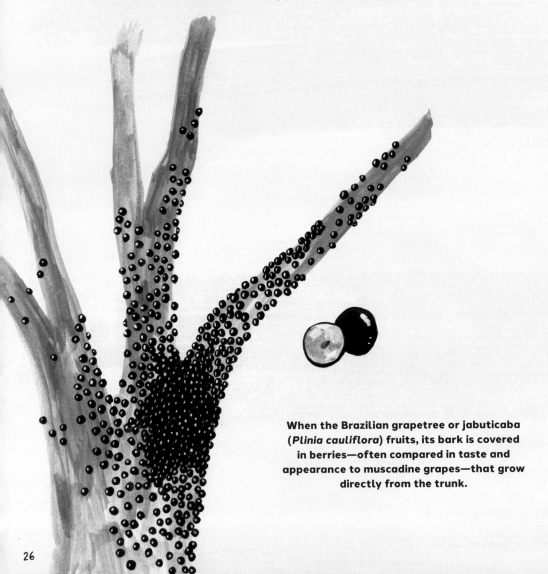

When the Brazilian grapetree or jabuticaba (*Plinia cauliflora*) fruits, its bark is covered in berries—often compared in taste and appearance to muscadine grapes—that grow directly from the trunk.

The pinkish beige and gray bark of the river birch (*Betula nigra*) flakes away from the tree in huge shaggy sheets as the tree matures.

The reptilian texture of the bark of the alligator juniper (*Juniperus deppeana*) gives the tree its name.

The Tibetan cherry (*Prunus serrula*) is a coveted garden variety known for its shining coppery red bark, striped with wide lenticels.

The ponderosa pine (*Pinus ponderosa*) has scaled bark that reddens as it ages; it famously smells like vanilla.

The bark of the Hercules' club (*Zanthoxylum clava-herculis*) is covered in spiny bumps.

Certain trees, including aspens (*Populus*), bear eye-shaped scars after dropping their lower branches.

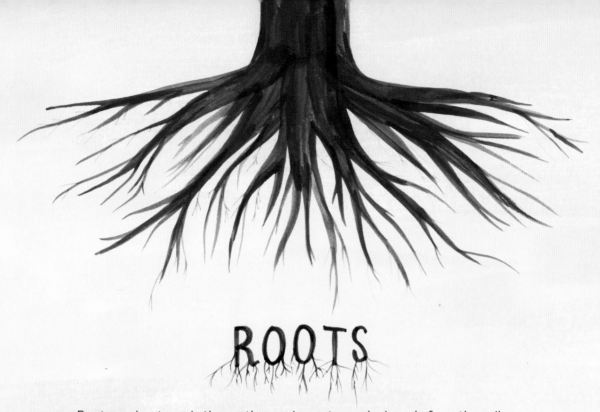

ROOTS

Roots anchor trees in the earth, acquire water and minerals from the soil, and store food. They tend not to be very deep—usually not more than a couple feet underground—and to spread widely—often up to two times the diameter of the tree's branches. Roots are thicker nearer the trunk and thin out as they spread farther from the tree. The tiniest roots of all are the single-cell-wide root hairs at the edges of the root growth, which can be even thinner than a human hair.

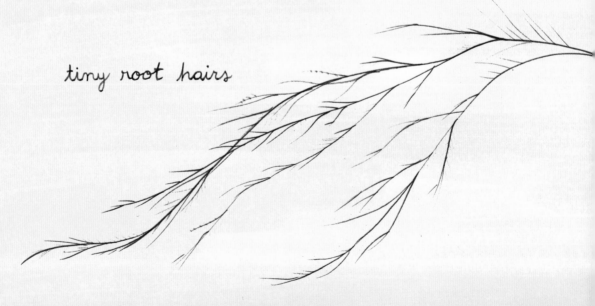

tiny root hairs

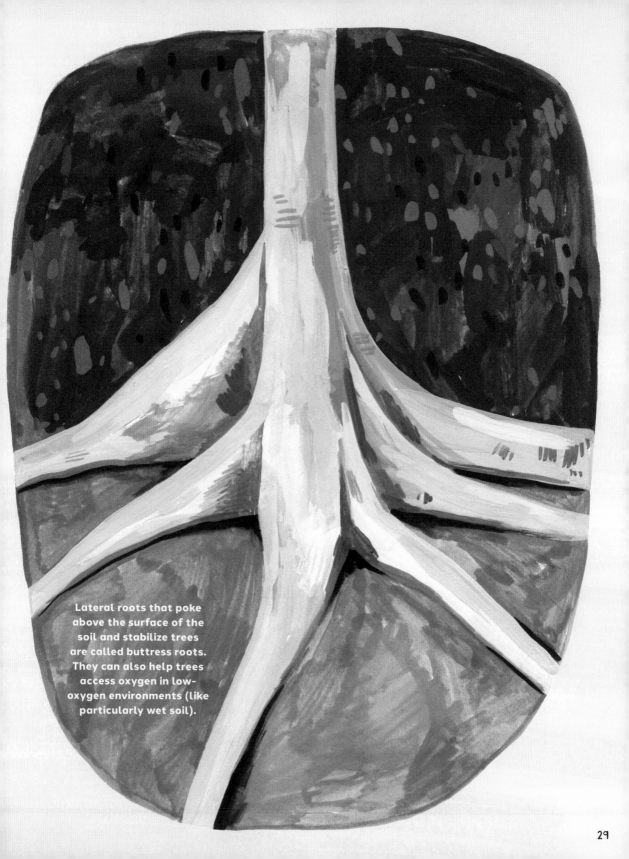

Lateral roots that poke above the surface of the soil and stabilize trees are called buttress roots. They can also help trees access oxygen in low-oxygen environments (like particularly wet soil).

CONES

Coniferous trees reproduce via cones. These are either female (the large, woody cones that we usually think of as pinecones) or male (the smaller, less conspicuous cones that produce pollen in springtime).

The longest cones of all are produced by the sugar pine (*Pinus lambertiana*); these regularly measure 14 inches (36 cm) in length. The largest by weight are the claw-like cones of the Coulter pine (*Pinus coulteri*), which average around 8 pounds (3.6 kg) apiece. Among the smallest cones are those of the tamarack (*Larix laricina*), often no larger than a blueberry.

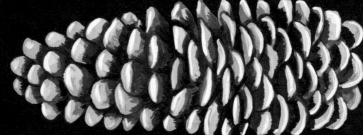

cone of the
SUGAR PINE

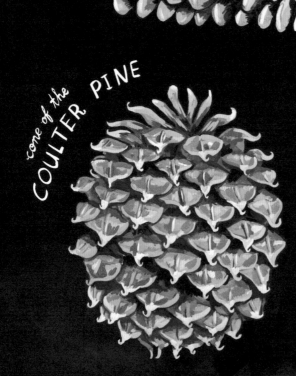

cone of the
COULTER PINE

female cone

The female and male cones of the Douglas-fir (*Pseudotsuga menziesii*) vary in size and color.

male cone

almonds

bay leaves

chocolate

cinnamon

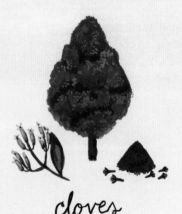

cloves

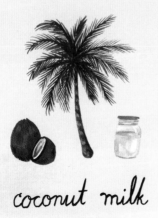

coconut milk

coffee

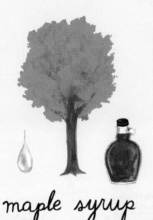

maple syrup

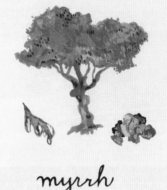

myrrh

GIFTS FROM THE ARBOR

Trees give us so much, but since we are often so removed from the source of the food and drink that we consume, we might not always remember where we get these daily staples. Such kitchen comestibles as olive oil, coffee, coconut milk, chocolate, and maple syrup all come from trees. Our spices do, too—cinnamon, nutmeg, cloves, and bay, for example—as do many of our nuts, including walnuts, cashews, almonds, chestnuts, macadamias, and pistachios. And, of course, trees give us an incredible bounty of fruits: bananas, apples, dates, stone fruits, citrus fruits, avocados, and more. Trees provide precious commodities and materials as well, such as ebony wood, myrrh, frankincense, henna, and latex.

nutmeg

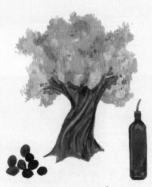

olive oil

peaches

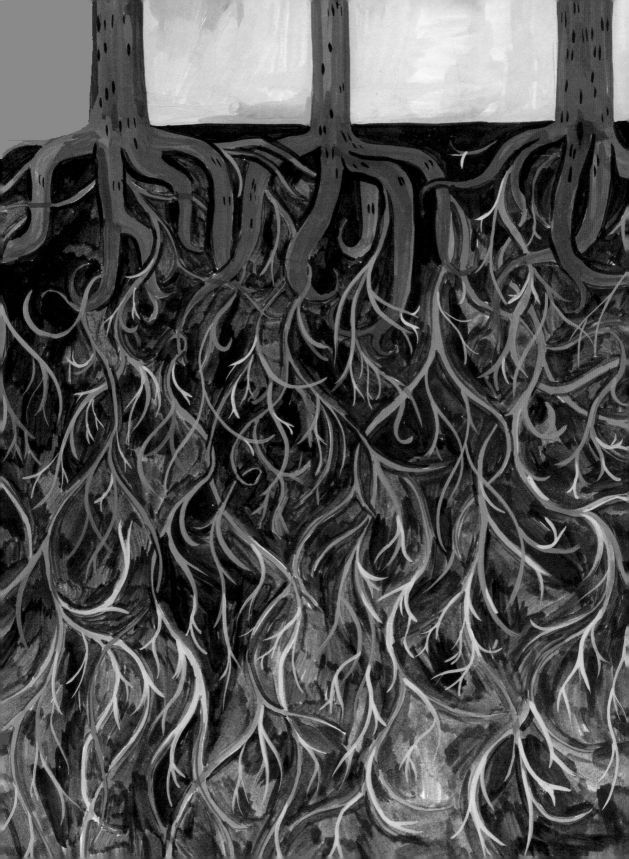

FUNGI

We're only now learning about the broader systems that roots tap into to keep trees healthy and flourishing. Enter mycorrhizae, whose name comes from a combination of *myco*—pertaining to fungi (as in *mycology*, the study of fungi)—and *rhizae*—root (as in *rhizome*, the horizontally running underground stems of a plant). Aided by fungi, tree roots access vast underground forest networks that allow both fungi and plants to exchange resources in a symbiotic relationship. Underground, fungi receive the excess sugars created by trees and other photosynthesizing plants; in turn they supply the plants with water and minerals they can extract from the soil.

Mycorrhizal networks are harder for us to see than trees are. Mycelia, the fungal tendrils that tie tree roots to one another, are usually buried under the forest floor. If you were to scoop up a handful of forest soil, you might see white threadlike fragments, but these are just a piece of the network—they only hint at the vast complexity of what's going on underground. Science has helped to illuminate and illustrate the ways those connections work. Modern commercial attitudes toward trees and forestry tend to focus on what is immediately visible to us: big trees as potential profit. But the beauty of mycorrhizae goes further than what is visible to the naked eye.

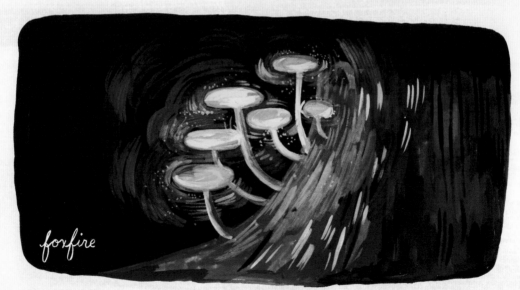

The green glow produced by bioluminescent fungi in the woods is called foxfire.

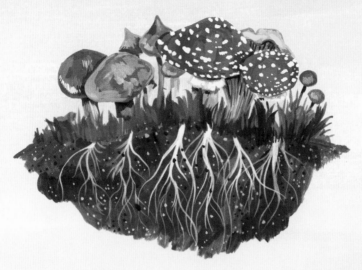

The fruiting bodies of a forest's fungi—mushrooms—peek their heads above the surface from time to time. There's hardly a better place to find mushrooms than the woods, and while they are just one small piece of the vast world of the undersoil and understory, they tend to be charismatic ambassadors of that otherwise nearly invisible world.

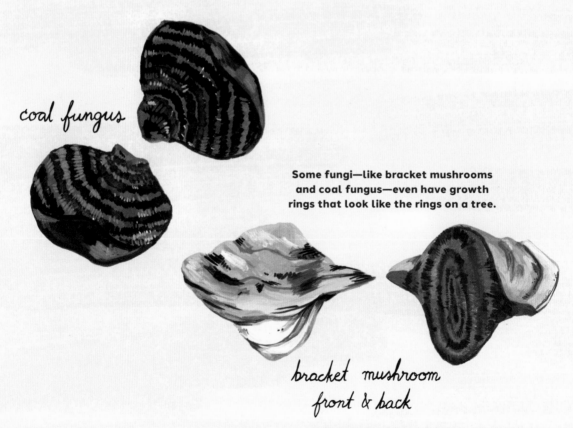

coal fungus

Some fungi—like bracket mushrooms and coal fungus—even have growth rings that look like the rings on a tree.

bracket mushroom
front & back

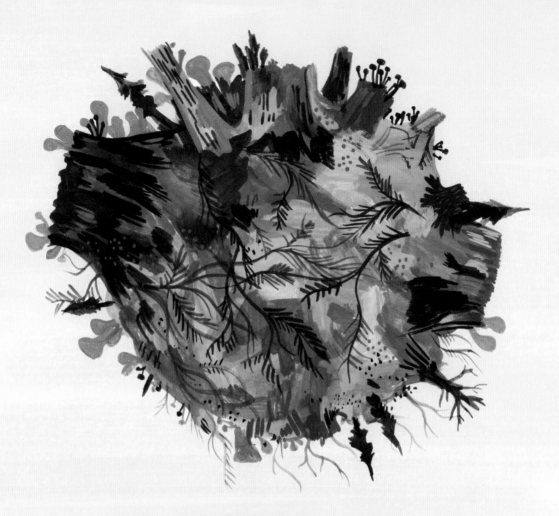

THE HUMONGOUS FUNGUS

Not all fungi are partners with trees—many are actually parasites. Honey fungus (genus *Armillaria*) is among the most notorious forest destroyers. The record for the largest biomass of any living organism on Earth is believed to be set by a honey fungus of the species *Armillaria ostoyae*. Nicknamed the Humongous Fungus (and how could it be called anything else?), this sprawling individual is estimated to weigh up to 35,000 tons, covers an area of 2,385 acres, and may be up to 8,650 years old. It's located in Oregon's Malheur National Forest, in the United States, where it has become so large by feeding on dead wood and colonizing and killing its tree hosts.

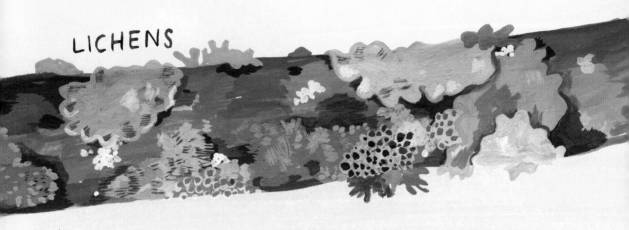

LICHENS

EPIPHYTES

Organisms that live on other plants but are not parasitic are called epiphytes. Lichens are composite epiphytes made of either algae or cyanobacteria in combination with fungi; they are often found on tree barks. Mosses can grow on a variety of surfaces in moist woodlands, including on trees. Flowering plants such as orchids and bromeliads are also common epiphytes. Spanish moss, a bromeliad and not a true moss, is often found dangling from the branches of live oaks and bald cypress trees.

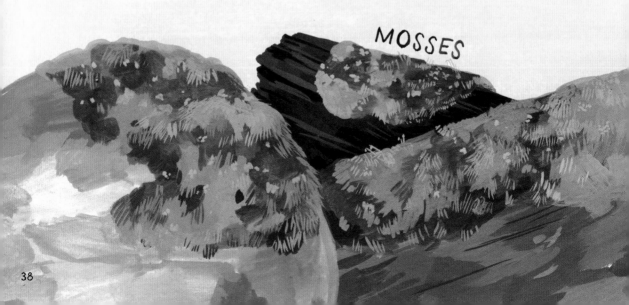

MOSSES

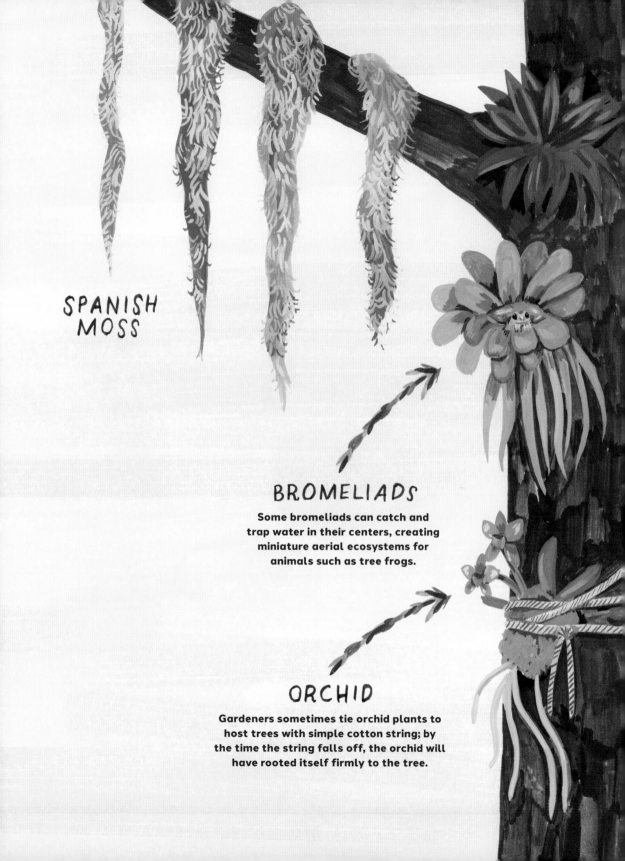

SPANISH MOSS

BROMELIADS

Some bromeliads can catch and trap water in their centers, creating miniature aerial ecosystems for animals such as tree frogs.

ORCHID

Gardeners sometimes tie orchid plants to host trees with simple cotton string; by the time the string falls off, the orchid will have rooted itself firmly to the tree.

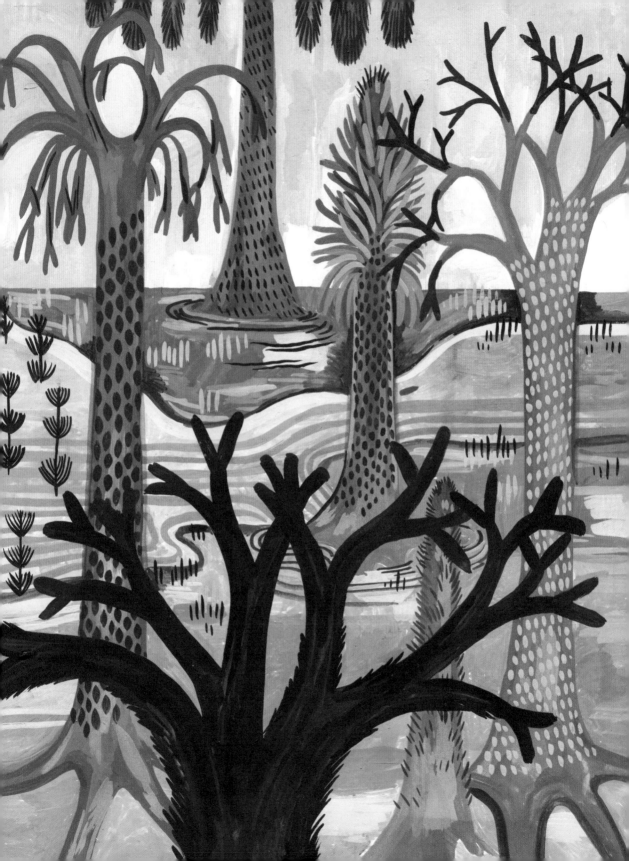

ANCIENT TREES

THE FIRST TREES

Thanks to paleobotany, the study of ancient plants, we're able to peer backward in time to the earliest trees and forests. *Archaeopteris* is thought to be the earliest tree, which also formed the earliest forests. Plants of this genus, known by the fossil evidence they left behind, had a tall woody trunk, branches, and a root system similar to that of today's trees. They developed during the Devonian Period—the earliest fossil forests from this time date back 385 million years.

Later, in the Carboniferous Period, a club moss relative called *Lepidodendron* began to grow to massive size, reaching 130 feet (40 m) in height. These so called scale trees, whose common name references their scaled bark, spread across the globe. They tended to grow quickly and left huge deposits of biomass in their wake. These eventually fossilized into coal deposits we now use for energy.

We can still see a living reminder of the history of these early trees in today's forests: the ground pine (*Lycopodium obscurum*) is a club moss, too, albeit a minuscule one. Its name is a perfect descriptor, as it looks like a miniaturized version of a pine tree—or, with a little imagination, a miniaturized version of a *Lepidodendron*. Try keeping an eye out for ground pines the next time you have a chance to walk in the woods, and be reminded of its prehistoric ancestors that once covered our world.

Archaeopteris *Lepidodendron*

AMBER

Some trees, when wounded, exude a resinous sap from their bark. When this hardens under the right conditions, it becomes amber, which can last for millions of years. Amber has been used as a semiprecious stone in art and jewelry making for thousands of years—Stone Age people carved animal figurines from amber. Since it starts out as a sticky liquid before hardening into stone, amber often includes bits of life that got stuck to, enveloped by, and ultimately preserved inside it—and not just plant life: perfectly encapsulated insects, spiders, and even small vertebrates, like frogs and lizards, are found in fossilized amber. All these animals can be studied in the present thanks to the resin drops formed from the trees of prehistoric forests.

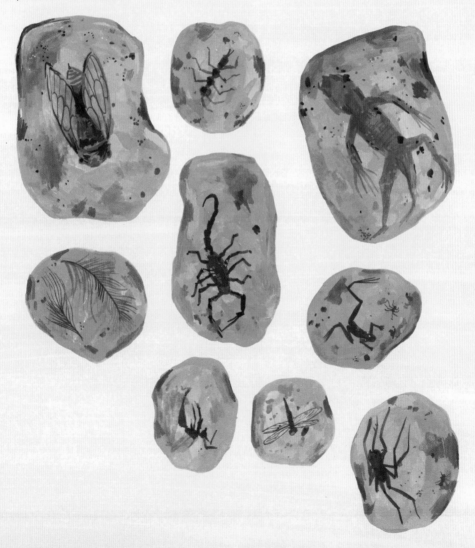

PETRIFIED WOOD

Wood becomes petrified, or turned to stone, when it is buried under sediment that prevents it from decomposing and minerals replace the organic materials over the course of time. In the right conditions, this can create a near-perfect replica of the original wood in inorganic form. Different minerals can combine during this process to create a variety of colors, giving some petrified wood varied and beautiful coloration. Sometimes, trees petrify so perfectly that their cell structure is preserved in rock form, providing even more fodder for the study of the ancient trees that shaped them.

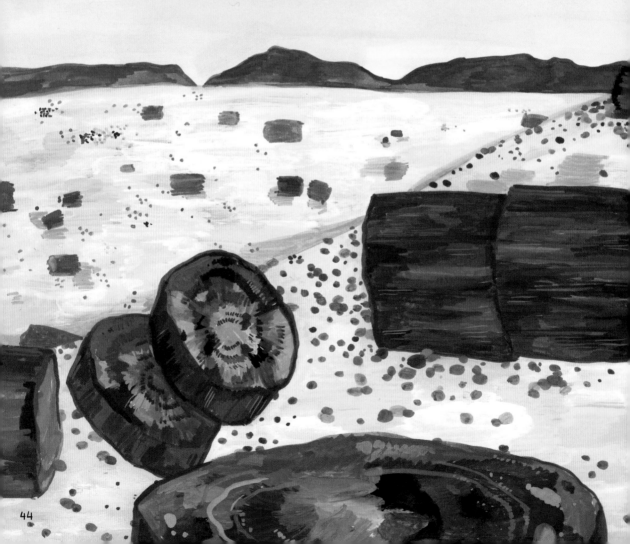

Entire forests can petrify, such as the one found in Arizona's Petrified Forest National Park, in the United States. Here, the fallen logs of conifers, tree ferns, and ginkgoes from forests of the Triassic Period collected in dense log jams and became petrified en masse. The trees lie scattered on the landscape like someone's long-forgotten log-splitting project—many, indeed, look as though someone took a chainsaw to them. In fact, petrified wood is extremely hard; it wasn't a saw that sliced these stone trees so cleanly, but stress caused by the gradual but significant rising of the plateau where they are found. This, as the National Park Service puts it, snapped the giant trees "like glass rods," though the "sawn-through" effect is so startling that the park's website has an entire page devoted to debunking it.

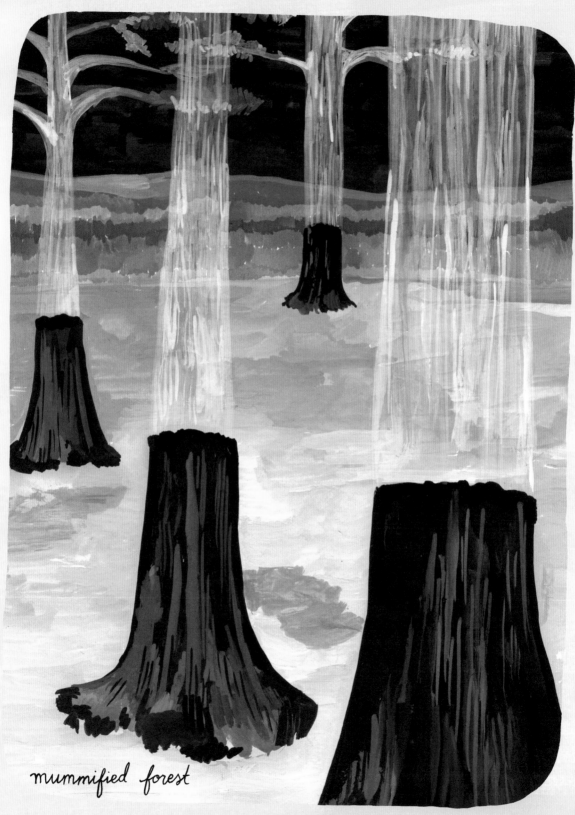

mummified forest

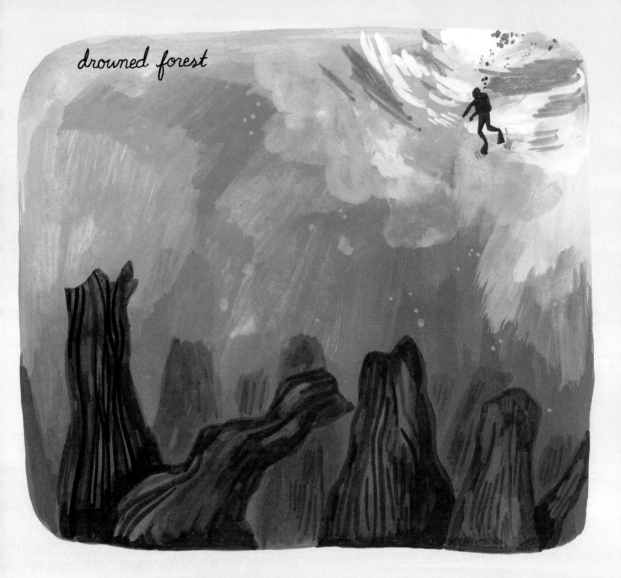

drowned forest

Mummified and drowned wood is also found all around the world. Unlike petrified trees, mummified and drowned trees haven't turned to stone but instead resisted decomposition altogether and are still made of the original wood. One site in Hungary, the Bükkábrány mummified forest, contained sixteen tree stumps standing upright after millions of years. They had been preserved by a coating of sand. A so-called underwater forest in the Gulf of Mexico—containing wood, roots, and even leaves, drowned and preserved by sediment underwater—was unearthed when Hurricane Ivan displaced the sand around the forest; it's estimated to be around 60,000 years old.

TREE CURIOSITIES

CROWN SHYNESS

Some tree species, such as lodgepole pine (*Pinus contorta*), maintain tidy margins of distance from one another at the canopy level, getting as close as they can without actually touching. This is known as crown shyness, and the cause is up for debate; it may be a measure to prevent the spread of disease, or a way to let a little light through to the forest floor, or it could merely be a byproduct of branches snapping off when they brush into each other.

INOSCULATION

Trees can inosculate, or connect and merge, to continue future growth together in a new form. In the wild, trees growing close enough to one another can self-graft (inosculate on their own), often to such an extent that a cross section of their trunk would show two sets of rings merging into one. Trees' ability to heal around any obstacles placed in their way can be exploited to mold them into curious and whimsical forms. It also lends stability and resilience to the grafting process.

UNDERGROUND TREES

Welwitschia mirabilis is a wholly unique plant growing in some of the harshest conditions on Earth—if you were to stumble across it, you might not register it as a tree at all. It grows directly out of the sandy gravel in the Namib Desert of southern Africa. Its name in Afrikaans is *tweeblaarkan-niedood*, which means "two leaves that cannot die," because it grows only two leaves, which are permanent, lasting the lifetime of the plant (up to several centuries). The leaves become buffeted and torn over time, giving them the appearance of a ribbonlike collection of many leaves, but functionally they remain just two and are able to condense moisture from the air. Underground, a hardwood column covered in corky bark can reach up to 13 feet (4 m) in length—this is the trunk that gives *Welwitschia* its occasional tree classification.

INFINITE SHOOTS

Coppicing and pollarding are two woodland management techniques that take advantage of many trees' tendencies to produce new growth from cut surfaces in long, straight shoots. Willows (genus *Salix*), with their straight even shoots, are a common choice for this technique, but many others are used as well. Coppicing is done at ground level, usually for the purpose of harvesting shoots for fuel, materials for basketry and fence making, charcoal for charcoal pencils, and any number of woodcrafting purposes that require rods or poles; it can also produce fodder for farm animals. Trees can be coppiced continuously, enabling their caretakers to harvest materials for years without killing the plant. Pollarding exploits the same principles as coppicing but is done higher up, often above the grazing line for hungry livestock. You might notice similar, albeit less intentional results in roadside pruning, where trees have been hastily cut in an attempt to clear sidewalks or other municipal areas. Certain pruning cuts that look tidy at first can soon blossom into unintended thickets—try looking along roadsides or by power lines in your town to see this phenomenon.

coppicing

pollarding

STORIES FROM
THE STARS

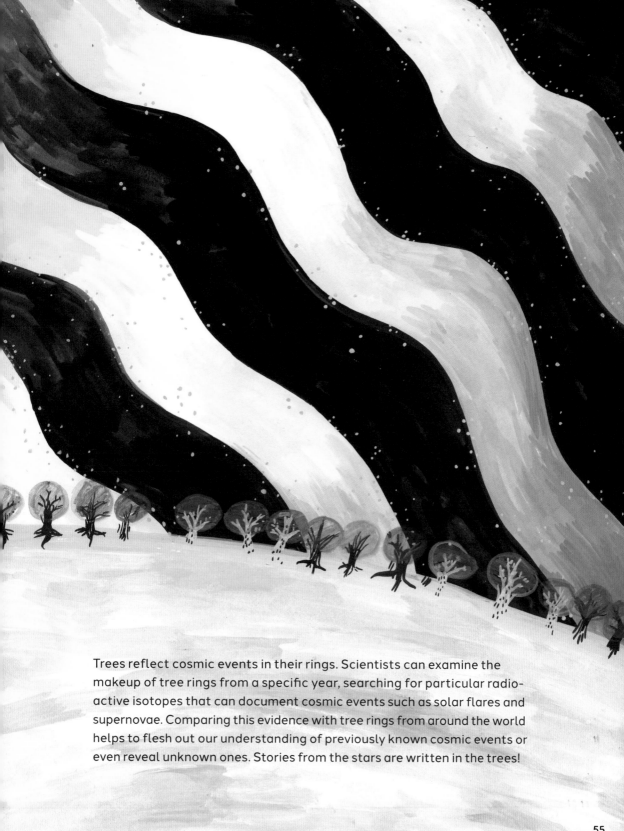

Trees reflect cosmic events in their rings. Scientists can examine the makeup of tree rings from a specific year, searching for particular radio-active isotopes that can document cosmic events such as solar flares and supernovae. Comparing this evidence with tree rings from around the world helps to flesh out our understanding of previously known cosmic events or even reveal unknown ones. Stories from the stars are written in the trees!

THE OGHAM TREE ALPHABET

The Ogham tree alphabet is an ancient Irish alphabet dating to as early as the third century CE; each character is associated with a different tree or shrub. The alphabet's history is somewhat muddled and its origins are unclear; it is known from a variety of old manuscripts and inscriptions on stone slabs and memorials across Ireland and Britain. There are twenty original characters in the alphabet, along with five additional characters or more (the exact number cited varies across sources), and each is made up of a vertical line with lines branching away from it. Tree names may have been ascribed to them many centuries after the creation of the alphabet, though even these monikers are many centuries old by now. And as Ogham is typically written in a vertical stack and joined along its "trunks," it indeed evokes the shape and form of trees.

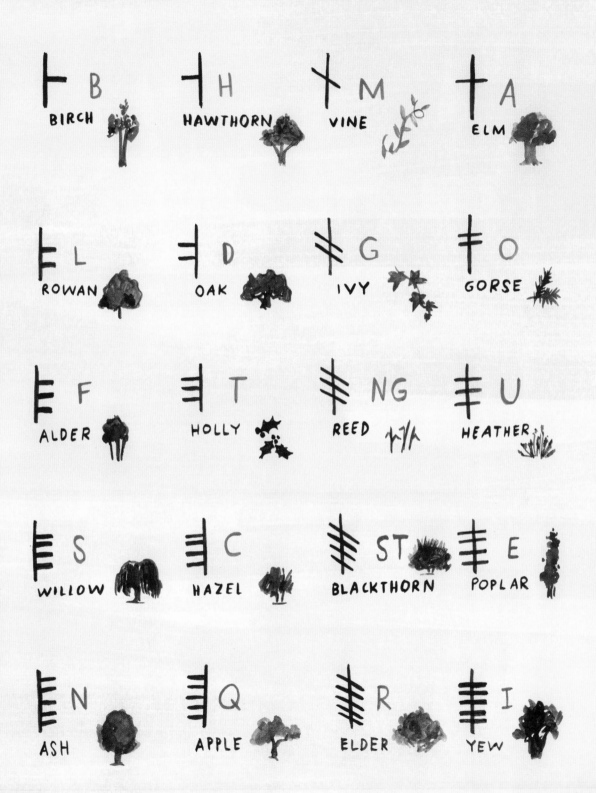

B BIRCH

H HAWTHORN

M VINE

A ELM

L ROWAN

D OAK

G IVY

O GORSE

F ALDER

T HOLLY

NG REED

U HEATHER

S WILLOW

C HAZEL

ST BLACKTHORN

E POPLAR

N ASH

Q APPLE

R ELDER

I YEW

THE TALLEST TREES

Scientists believe the maximum possible height for any tree is approximately 426 feet (130 m), and the tallest trees in the world reach just below this limit. Even if conditions are perfect, tall trees must fight against gravity and other physical constraints to deliver water to all their leaves.

The coast redwood (*Sequoia sempervirens*), which belongs to the cypress family, is descended from evergreen conifers that were once distributed throughout the Northern Hemisphere and are found among the forests of the California and Oregon coasts. It can grow to more than 300 feet (91 m) tall; a coast redwood named Hyperion is the world's tallest living tree, at 380 feet (115 m). The superlative height of the redwoods is nearly matched by their long life spans; individuals can live over 2,000 years, and fossil evidence from petrified trunks evinces even longer life spans in prehistoric redwoods.

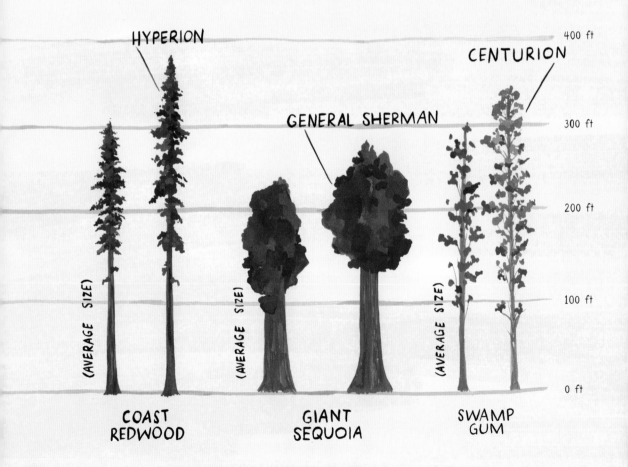

HYPERION

CENTURION

GENERAL SHERMAN

400 ft

300 ft

200 ft

100 ft

0 ft

(AVERAGE SIZE)

(AVERAGE SIZE)

(AVERAGE SIZE)

COAST REDWOOD

GIANT SEQUOIA

SWAMP GUM

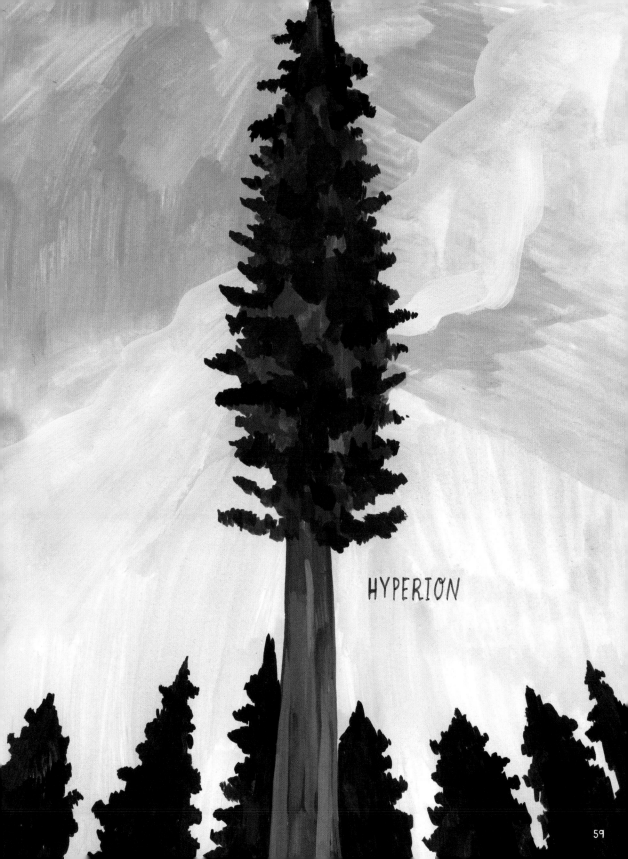

HYPERION

GENERAL
SHERMAN

Though not quite as tall as coast red-woods, giant sequoias (*Sequoiadendron giganteum*)—also related to cypress—are bigger by volume, making them the largest trees, and the largest living organisms, on Earth. Their heights generally range from 100 to 250 feet (30 to 76 m) and their diameters from 20 to 26 feet (6 to 8 m). The largest individual currently living is 275 feet (84 m) tall—General Sherman, whose trunk measures 36 feet (11 m) in diameter at its base and 14 feet (4 m) in diameter at 180 feet (55 m) above its base. Giant sequoias also boast staggering life spans, living up to 3,500 years.

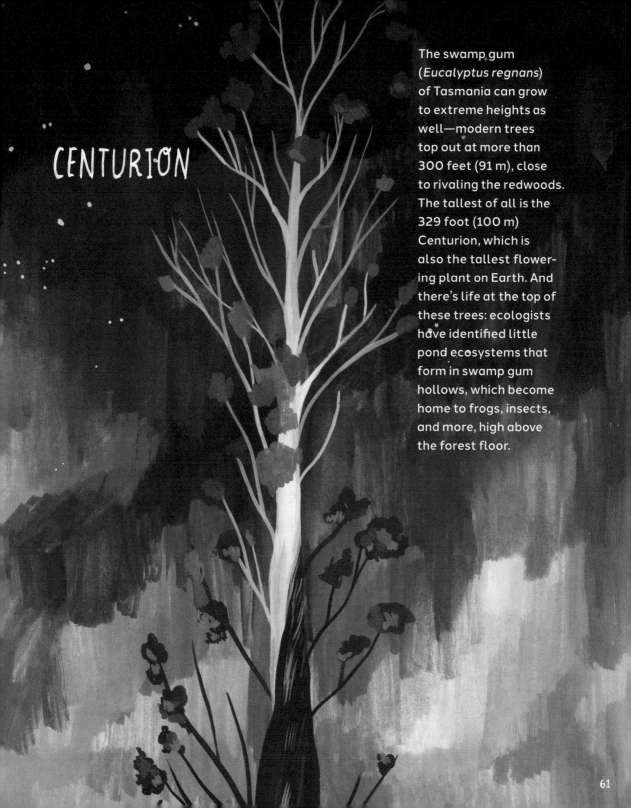

CENTURION

The swamp gum (*Eucalyptus regnans*) of Tasmania can grow to extreme heights as well—modern trees top out at more than 300 feet (91 m), close to rivaling the redwoods. The tallest of all is the 329 foot (100 m) Centurion, which is also the tallest flowering plant on Earth. And there's life at the top of these trees: ecologists have identified little pond ecosystems that form in swamp gum hollows, which become home to frogs, insects, and more, high above the forest floor.

THE OLDEST TREES

METHUSELAH

Methuselah, a Great Basin bristlecone pine (*Pinus longaeva*) is the oldest known individual (nonclonal) tree on Earth; it's an estimated 4,852 years old. Named after the biblical figure who was said to be 969 years old at his death, the tree was already hundreds of years old by the time the Great Pyramids of Giza were completed. It is still growing in the Ancient Bristlecone Pine Forest of Inyo County in eastern California. No confirmed photographs of Methuselah have ever been published, and its location is kept secret to avoid inadvertent damage by curious human onlookers.

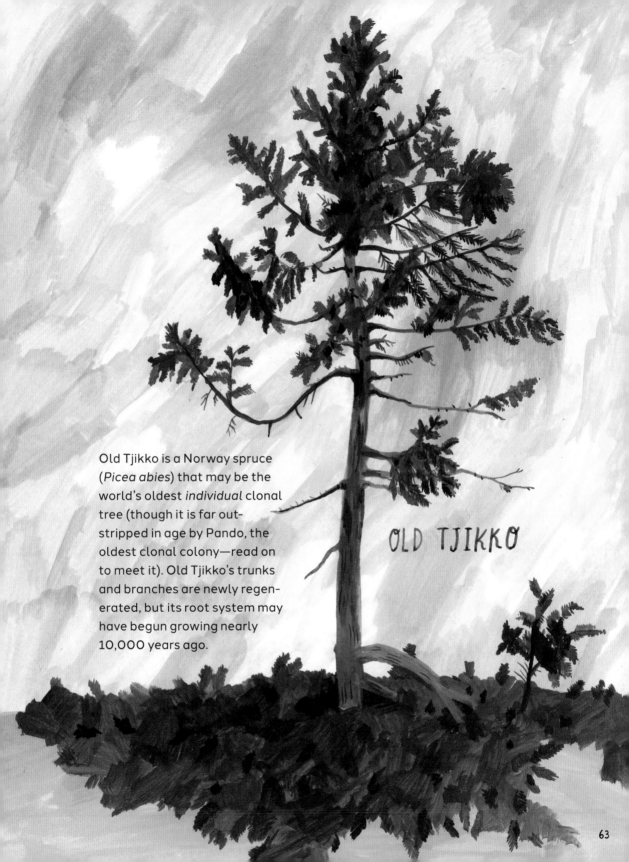

Old Tjikko is a Norway spruce (*Picea abies*) that may be the world's oldest *individual* clonal tree (though it is far out-stripped in age by Pando, the oldest clonal colony—read on to meet it). Old Tjikko's trunks and branches are newly regen-erated, but its root system may have begun growing nearly 10,000 years ago.

OLD TJIKKO

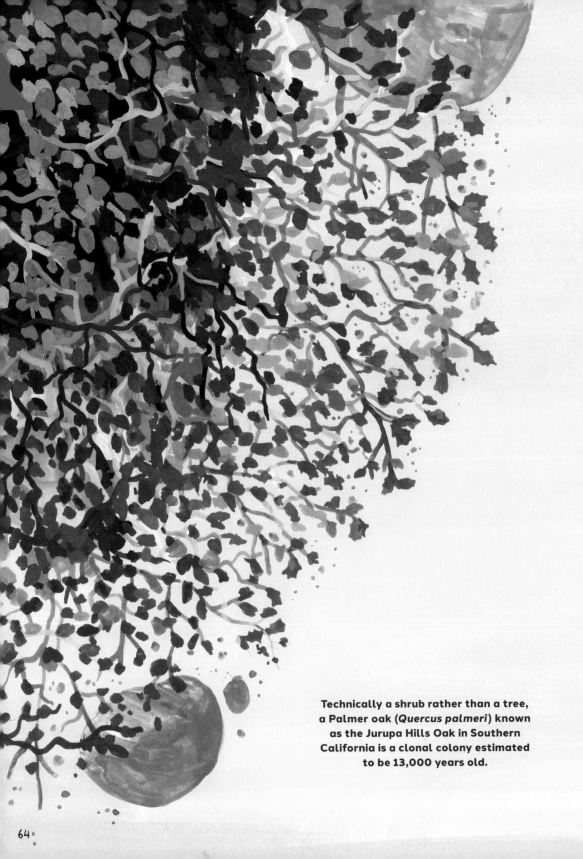

Technically a shrub rather than a tree,
a Palmer oak (*Quercus palmeri*) known
as the Jurupa Hills Oak in Southern
California is a clonal colony estimated
to be 13,000 years old.

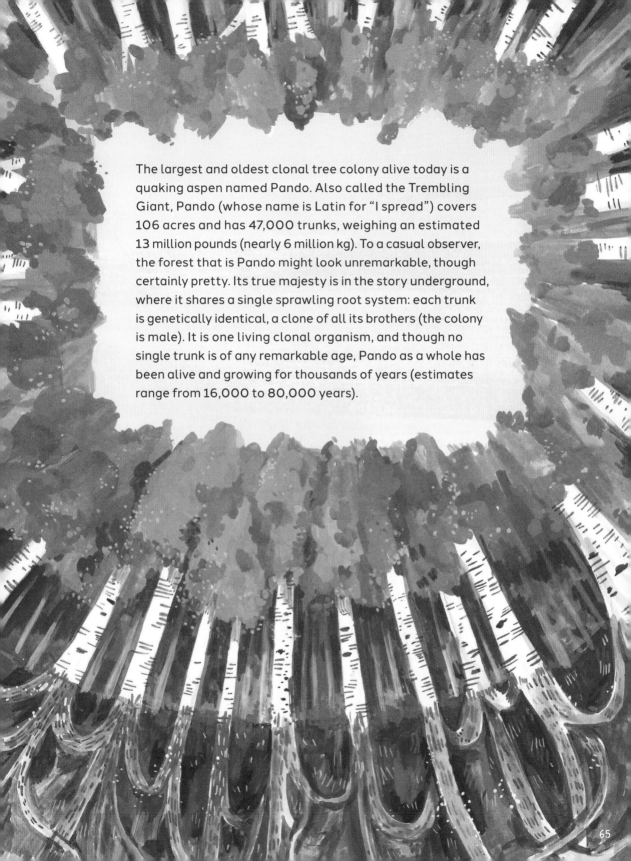

The largest and oldest clonal tree colony alive today is a quaking aspen named Pando. Also called the Trembling Giant, Pando (whose name is Latin for "I spread") covers 106 acres and has 47,000 trunks, weighing an estimated 13 million pounds (nearly 6 million kg). To a casual observer, the forest that is Pando might look unremarkable, though certainly pretty. Its true majesty is in the story underground, where it shares a single sprawling root system: each trunk is genetically identical, a clone of all its brothers (the colony is male). It is one living clonal organism, and though no single trunk is of any remarkable age, Pando as a whole has been alive and growing for thousands of years (estimates range from 16,000 to 80,000 years).

ANIMALS & TREES

Trees are home to many animals, and it seems that our excitement about those animals can often eclipse our excitement for the trees themselves. But though trees may seem less alluring than animals—they're not masters of flying or fighting, they don't rear live young—they are much more accessible. They stay put for observation! And they don't tend to mind being touched, recorded, listened to, or sniffed. Although, thanks to careful observation by tree watchers around the world, we know that, in a way, many trees actually *are* flight experts, dispersing aerodynamic seeds. And some trees *do* fight, as when they cooperate to make their leaves inedible after they detect a pest attack. Some trees can even rear live young! (Read about mangroves on page 84.) As for arboreal animals, there are some that never leave the treetops at all—many monkeys only venture to the forest floor if branches from one tree don't reach out far enough to allow them to jump to another. Sloths, mysteriously, only descend from their perches to defecate, before clambering back up to safety. Certain animals take their names from the trees. And while you may have heard of some of these before—like tree frogs—others remain less widely familiar. The tree kangaroo (related to ground-dwelling kangaroos) has adapted to arboreal life, with shorter legs and improved climbing capability. Tree snails spend their entire lives in trees (many have remarkably colorful patterned shells). Tree snakes live arboreally, too, where they have developed unique methods of climbing vertically—an adaptation as fascinating to many as it is horrifying to those who fear snakes.

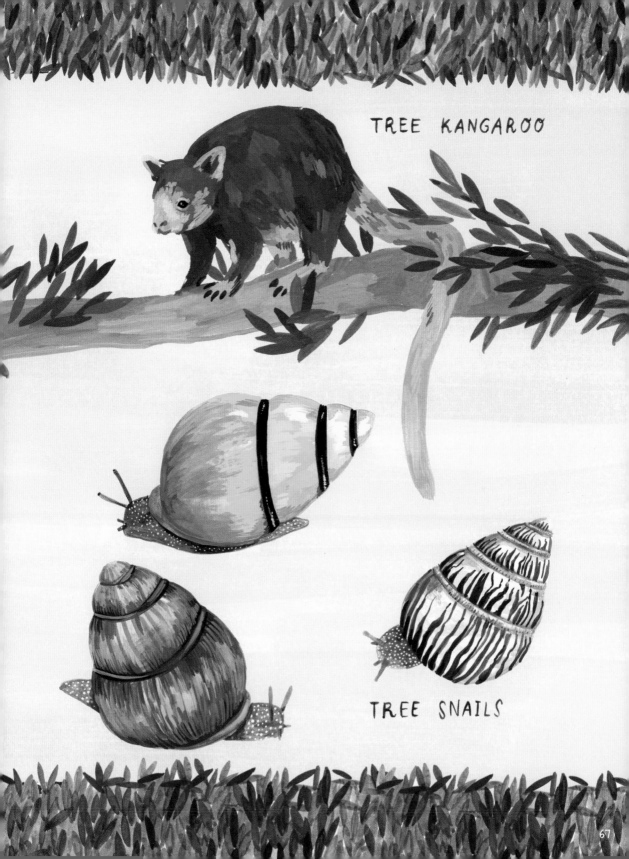

TREE KANGAROO

TREE SNAILS

OTHER "FORESTS"

Trees and shrubs shaped by humans into boundaries around farms and roads are called hedgerows. They're traditionally made by strategic bending and pleaching of foliage so they grow in one continuous, interconnected stretch. Originally built to delineate property, they've become connected networks of miniature habitat for animals, like hedgehogs. Sadly, their numbers are now dwindling. As small farms are consolidated into larger ones, hedgerows are being removed. Advocates suggest that restoration of hedgerows could restore the strength of this network and increase vulnerable populations.

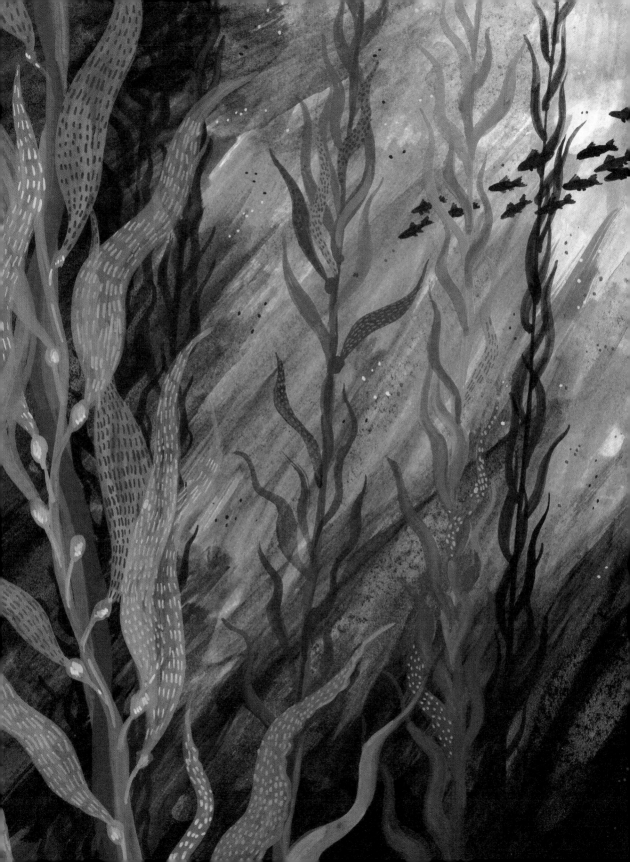

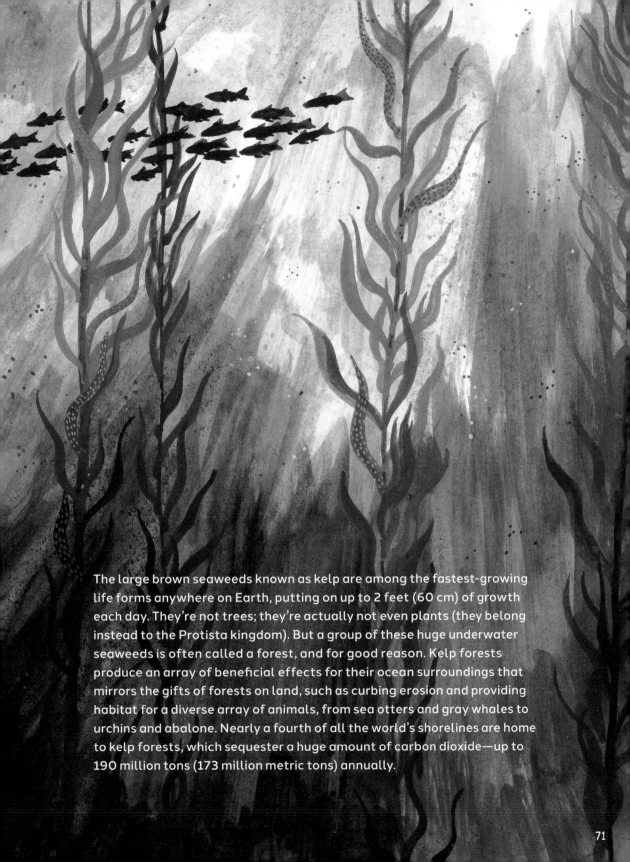

The large brown seaweeds known as kelp are among the fastest-growing life forms anywhere on Earth, putting on up to 2 feet (60 cm) of growth each day. They're not trees; they're actually not even plants (they belong instead to the Protista kingdom). But a group of these huge underwater seaweeds is often called a forest, and for good reason. Kelp forests produce an array of beneficial effects for their ocean surroundings that mirrors the gifts of forests on land, such as curbing erosion and providing habitat for a diverse array of animals, from sea otters and gray whales to urchins and abalone. Nearly a fourth of all the world's shorelines are home to kelp forests, which sequester a huge amount of carbon dioxide—up to 190 million tons (173 million metric tons) annually.

TROPICAL TREES

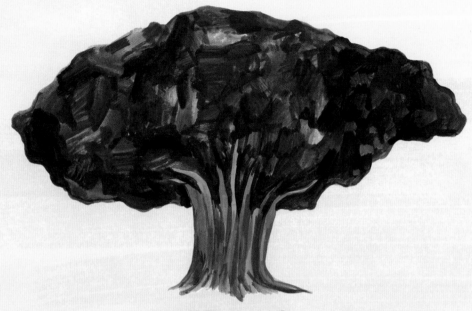

FICUS

Also called the Bo tree or Bodhi tree, the sacred fig (*Ficus religiosa*), native to South and Southeast Asia, is an important symbol across many cultures and religions. In Buddhism, this is the tree under which the Buddha attained enlightenment; because of their sacred nature, these trees are often allowed to grow in, on, or even through the structures of temples and other buildings. Many sacred figs around the world are believed to be descendants of the Buddha's very tree and are now sacred sites of pilgrimage themselves.

The rubber plant (*Ficus elastica*) is a related species. As a houseplant, this fig can fit on a windowsill; but in the wild it can grow to be a tree up to 200 feet (60 m) tall. It produces natural rubber but has given up its place of prominence to the Pará rubber tree (*Hevea brasiliensis*), which is now the world's primary source of natural rubber.

BANYAN

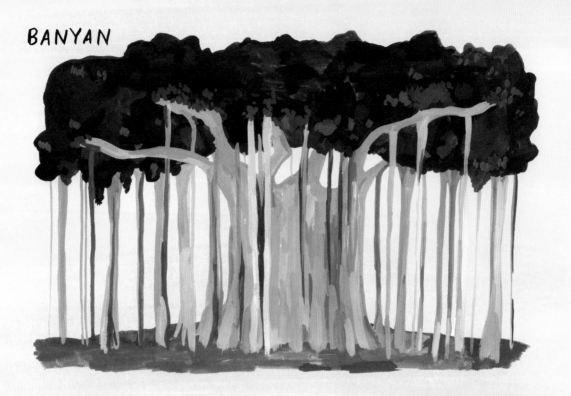

Figs spread in unique ways. The banyan (*Ficus benghalensis*) drops aerial prop roots from its branches, which eventually thicken into secondary trunks, supporting the banyan as it spreads to cover up to several acres. From a distance, a single tree can look like a small forest. And several species of figs called strangler figs start their lives as epiphytic vines, growing on and around their host trees. They can grow so large that they overtake the original trees and then persist as large, hollow living columns once the support trees decompose.

STRANGLER FIG

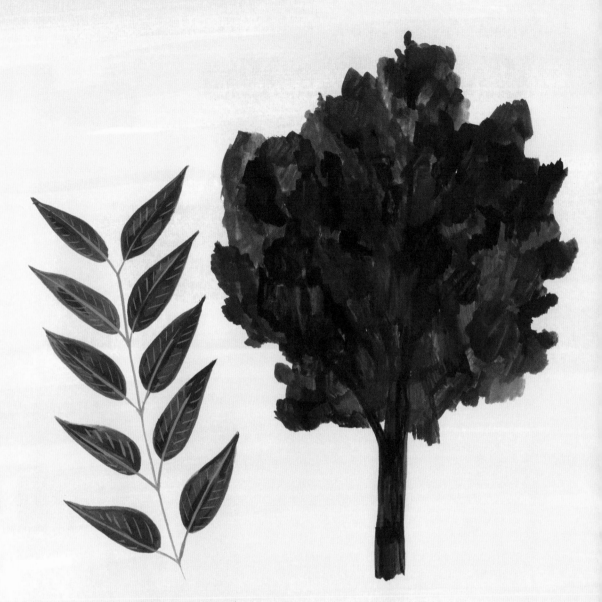

MAHOGANIES

The so-called true mahoganies of the genus *Swietenia* are native to Central and South America. They're famous for their highly desirable timber, sometimes called "red gold." They grow slowly and produce diamond-hard wood, which shines like a precious metal when polished. This coveted tree has become overharvested in the wild, so it is also cultivated widely.

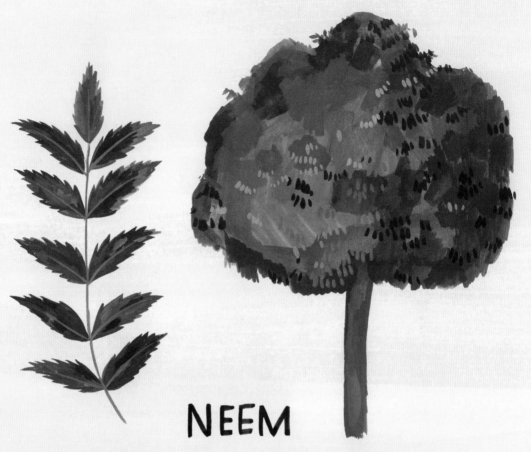

NEEM

The neem tree (*Azadirachta indica*) is known for its medicinal properties—it produces a key component in countless cosmetics and medicines in India, and neem twigs are even used as toothbrushes. It also has a remarkable ability to ward off insects; compounds that repel pests permeate nearly every part of the tree. Oil made from the tree is used as a pesticide spray, neem leaves can be placed in between the pages of a book to avert pests, neem lumber can deter termites, and neem trees grown alongside cultivated crops can even protect them from insects.

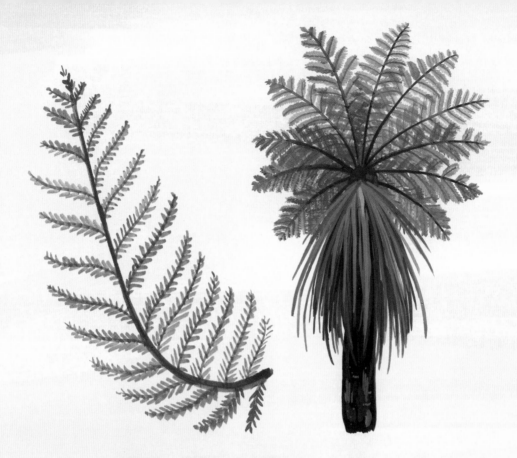

TREE FERNS

Though ferns—what kind, where, how many—can reveal a lot about a forest floor, ferns themselves don't often grow to the size or form of trees. But certain ferns from the order Cycatheales, and particularly those belonging to the family Cyatheaceae, can grow thick, rigid trunks. This is enough to land them in the tree category, even though they don't usually branch, and they also lack a true bark (instead, they are coated in the scaly remains of former leaves). Tree ferns evoke a sense of deep prehistory, looking like the backdrop to the time of the dinosaurs (which they were).

The kātote (*Cyathea smithii*) is also called the soft tree fern. Its trunk, which can grow to 26 feet (8 m) tall, is wreathed in the long, dangling remains of its old leaves. The man fern (*Dicksonia antarctica*—also called the soft tree fern) lacks the large underground root system of most other trees, so it can survive being more or less hacked off at the base and replanted, where it can quickly establish new roots and continue to grow.

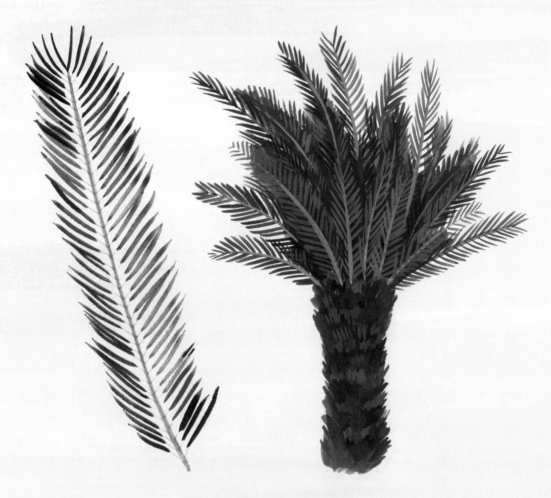

CYCADS

Somewhat palmlike, somewhat fernlike, and closely related to neither, prickly cycads (order Cycadales) are popular ornamental plants with origins in the Mesozoic Era. Having evolved around 300 million years ago (the exact date is controversial), cycads are the oldest surviving seed-plant branch on the tree of life. Their long, cylindrical trunks typically do not branch at all; they are covered in leaf scars and topped with sprays of stiff pinnate leaves. Of the three hundred or so species of cycad, some are small and shrublike, while others, like Hope's cycad (*Lepidozamia hopei*), can top out at more than 66 feet (20 m) in height.

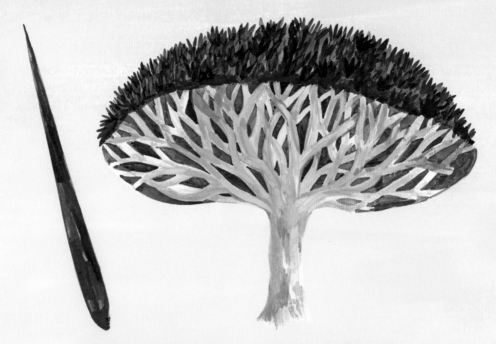

DRAGON TREES

Endemic to the remote Yemeni island of Socotra, the dragon blood tree (*Dracaena cinnabari*) bleeds red sap when cut. El Drago Milenario (the Millennium Dragon Tree)—an individual of the related species *Dracaena draco*, which also bears red sap—is believed to be the oldest and largest tree of its kind. El Drago Milenario grows on Tenerife in the Canary Islands, and its name suggests its age is thousands of years or more. Its actual age is debated; it's likely nowhere close to that old, but its superlative size—more than 65 feet (20 m) tall, well over the average size for the species—is enough to have made it a national monument. Another Socotran tree is the Socotran desert rose (*Adenium obesum*), a stout little tree with a trunk that swells to portly proportions when storing water.

SAP

SOCOTRAN
DESERT ROSE

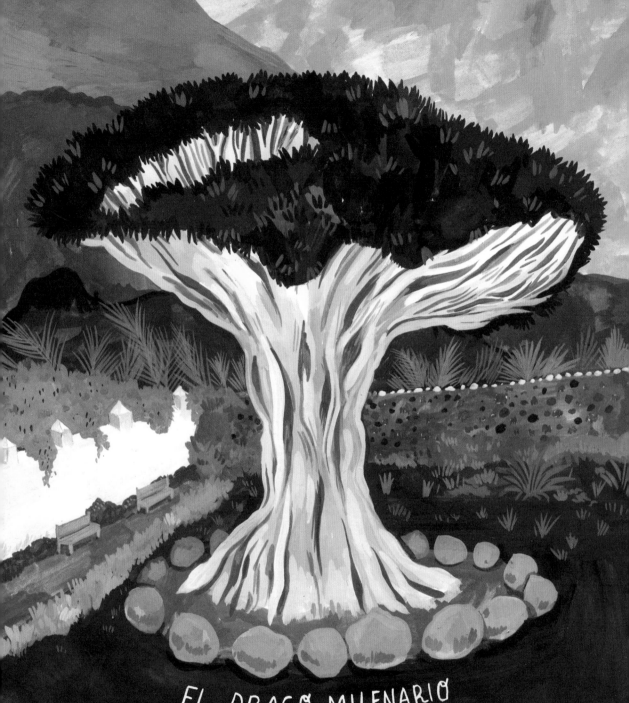

EL DRAGO MILENARIO

EUCALYPTUS

There are hundreds of species of eucalyptus (genus *Eucalyptus*), also known as gum trees, native throughout Australia and Oceania. The silver dollar branches found at the florist's shop come from juvenile eucalyptus, but as the trees mature, they produce longer, greener leaves that look like they've come from a different tree altogether. Cider gum (*Eucalyptus gunnii*) can be coppiced to continually create fresh young shoots for floral arrangements.

The fruit that encases eucalyptus's seeds looks a bit like a miniature vase capped with a button—like something off a forest fairy's mantlepiece. These seeds give the urn gum (*Eucalyptus urnigera*) its name. When the rainbow eucalyptus (*Eucalyptus deglupta*) sheds its bark, it reveals a bright green inner layer, which ages to orange, red, and purple. As different strips peel away and are exposed for different lengths of time, the tree becomes zebra-striped with the resulting variety of colors.

JUVENILE EUCALYPTUS BRANCHES

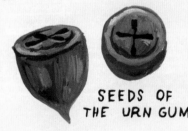

SEEDS OF THE URN GUM

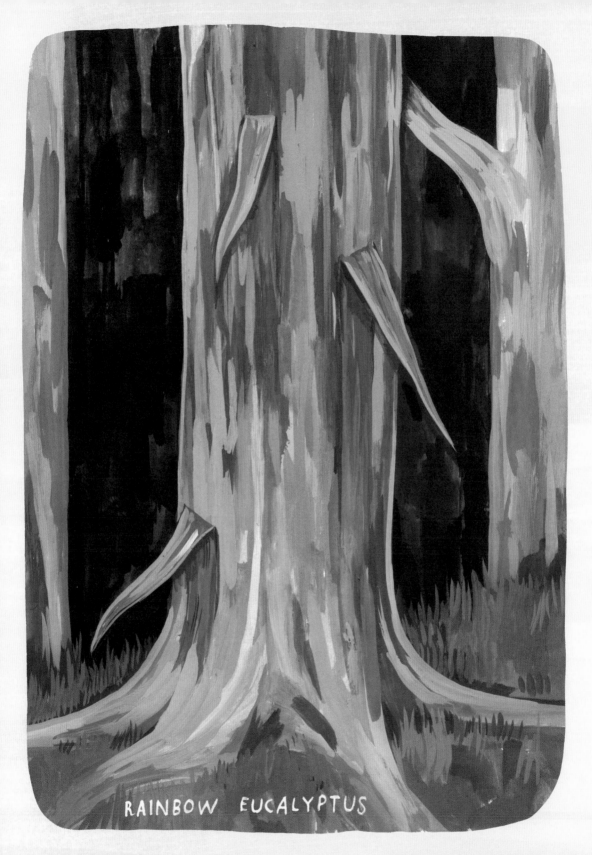

RAINBOW EUCALYPTUS

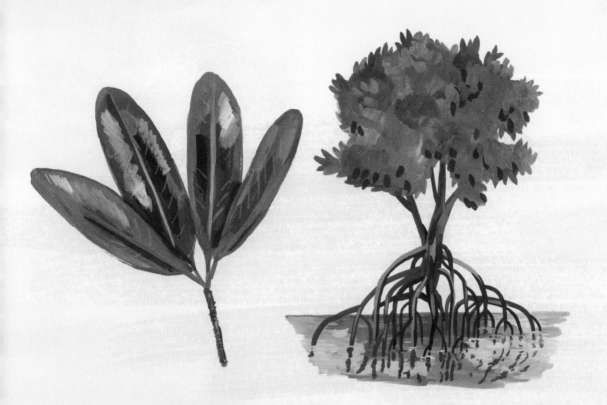

MANGROVES

The tangled thickets of roots that make up true mangroves (genus *Rhizophora*) are oddities among the world's trees. They grow on coastlines directly out of the water, and since the water they live in is brackish (and sometimes even true saltwater), they've had to evolve some extreme and ingenious methods for survival. Mangroves filter and excrete so much salt that their surfaces would taste salty if you licked them. Their leaves are thick, like succulents, storing fresh water for the tree. Their roots breathe through specialized pores that can open when exposed to air and close to keep water out during higher tides. The environments to which mangroves have adapted are so harsh that trees have evolved a unique way to care for their young: mangrove seedlings often grow right on the branch of their parent tree, giving them a head start on life in their challenging tidal habitat. And even after they grow mature enough to drop off of the parent plant, seedlings that can't immediately find a muddy spot in which to take root can survive floating in the water until they touch good land—even if it takes a year or more to find their new home.

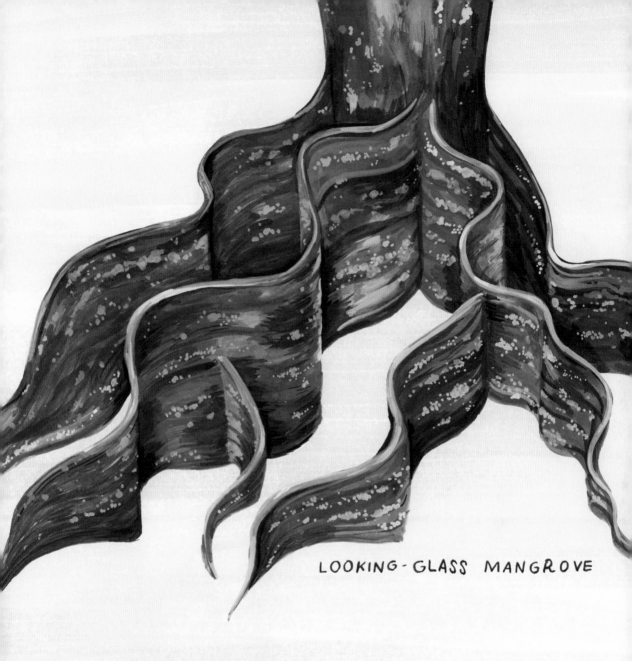

LOOKING - GLASS MANGROVE

The looking-glass mangrove (*Heritiera littoralis*)—which is not a true mangrove but so named for its similar growing style—has impressive buttress roots that seem to be formed out of enormous flat ribbons of tree matter. Their common name references the undersides of their leaves, which are a reflective near-white.

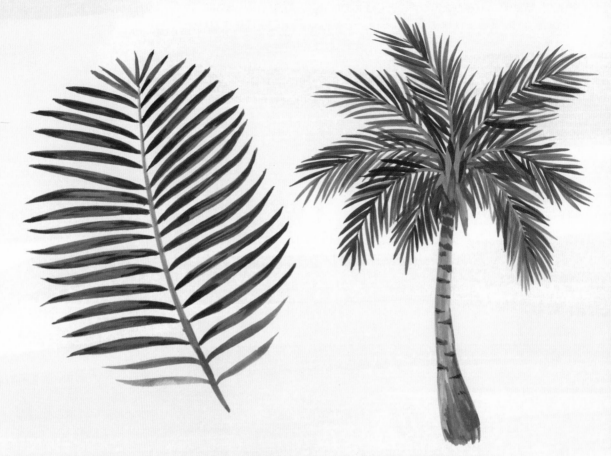

PALM TREES

Shrubs and trees of the family Arecaceae are known as palms. There are around 2,600 species in this family—almost all native to the tropics and subtropics—that range in form from treelike or shrublike to even vinelike. Their evergreen leaves can be palmately or pinnately compound. Palm trees can grow with a singular vertical trunk or as a cluster.

Coconut palms (*Cocos nucifera*) provide coconuts, of course, as well as building materials—their leaves are traditionally used for thatching, their trunks for timber, and their coir (the fibrous matter harvested from the shell of the coconut) for woven goods and as a popular soil amendment. They can grow to 100 feet (30 m) tall and are cultivated in warm regions all around the world.

The sealing wax palm (*Cyrtostachys renda*), also commonly cultivated in tropical areas, is named for its bright red stems. The jaggery palm (*Caryota urens*) is native to South and Southeast Asia and yields jaggery, a sugar obtained by boiling the palm's sap. The areca palm (*Areca catechu*) is distributed across Malaysia, Indonesia, and the Philippines and cultivated in other warm regions of the world. Its fruit, the betel nut, is chewed in many South Asian and Asian Pacific countries. Betel nut chewing dates back at least 2,000 years, and it remains a common cultural practice despite a host of associated health risks, including cancer. The date palm (*Phoenix dactylifera*) has been cultivated for thousands of years; its sweet fruit is eaten around the world.

A relatively new discovery, first officially described by scientists in 1978, the foxtail palm (*Wodyetia bifurcata*) of Australia has since become popular in landscaping. The once-rare tree's common name honors its bushy, arcing fronds; its scientific name comes from the name of the Aboriginal man, Wodyeti, who first brought the knowledge of its existence to the wider world.

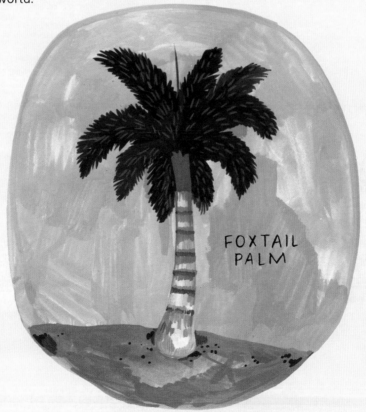

FOXTAIL PALM

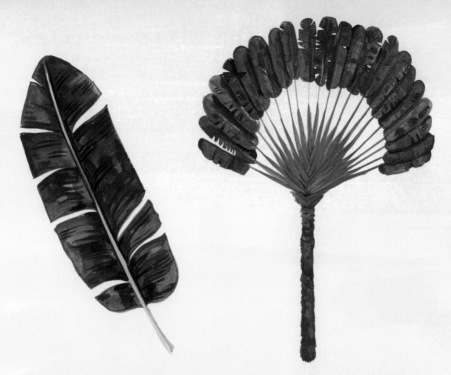

TRAVELER'S TREE

The enigmatically named traveler's tree (*Ravenala madagascariensis*) is a striking symbol of the tropics. Sometimes called the traveler's palm, this bizarrely shaped tree is actually not a palm at all, but a relative of the bird of paradise plant. Its name is somewhat of a mystery; a common explanation points to the tree's tendency to hold pooling water in its branches, supposedly a potable source of hydration for thirsty human travelers (though dissenters doubt that this stagnant water would have been considered drinkable). Another explanation for the name is that it comes from the tree's supposed tendency to always grow facing the same cardinal direction, acting as a navigational aid for travelers. This is dubious as well, as gardeners who grow this tree note that it actually doesn't always face the same direction.

Its leaves fan out evenly above a palmlike trunk, which can grow to nearly 60 feet (18 m) tall. Perhaps even more unusual are the tree's seeds, which are a bright teal color rarely seen anywhere else in the plant world. These are thought to have coevolved with one of the plant's pollinators, the ruffed lemur, whose eyes can differentiate between blue and green but can't see reds—the traveler's tree's seeds likely became blue because hungry lemurs could find them.

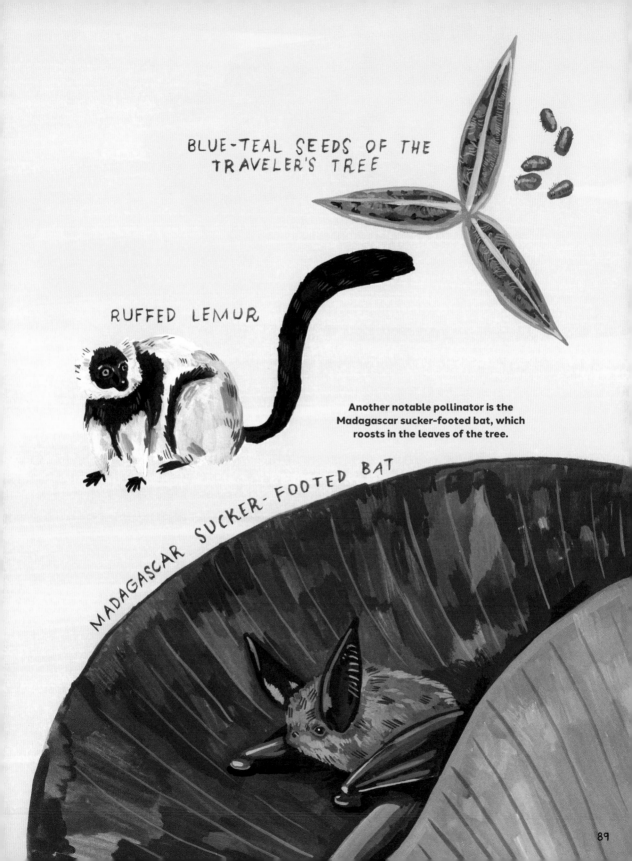

BLUE-TEAL SEEDS OF THE TRAVELER'S TREE

RUFFED LEMUR

Another notable pollinator is the Madagascar sucker-footed bat, which roosts in the leaves of the tree.

MADAGASCAR SUCKER-FOOTED BAT

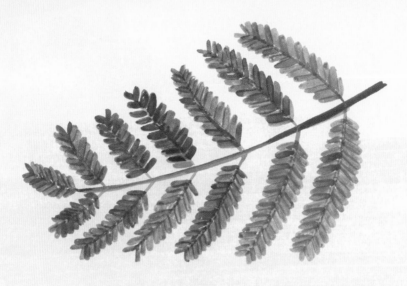

ACACIAS

There are around 160 species in the genus *Acacia*. Also called wattles, these trees and shrubs generally grow in hot desert climates. As part of the legume family, their seeds grow in long pods. Acacias are recognizable by their pinnate leaves, which give the trees a feathery appearance; many species have attractive and colorful flowers as well. The koa (*Acacia koa*) is native to Hawai'i, where it has traditionally been used to make dugout canoes. Today it suffers from overharvesting—its prized red wood is one of the most expensive lumbers in the world—as well as damage by invasive pests. Another notable species is the mimosa tree (*Acacia dealbata*), which grows in temperate regions and is prized for its frothy yellow sprays of flowers, which are commonly used in floral arrangements.

The umbrella thorn acacia (*Vachellia tortilis*), which is closely related to the acacias of the genus *Acacia* proper, has long been emblematic of the African savanna, where its canopies grow in the tree's namesake shape. It's also known for its ability to communicate with other trees of its species. When a giraffe chews on an umbrella thorn acacia, the tree emits an ethylene gas that indicates distress to the trees around it. When this airborne warning reaches neighboring trees, they respond by increasing the tannins in their leaves, making them unpalatable to the giraffes.

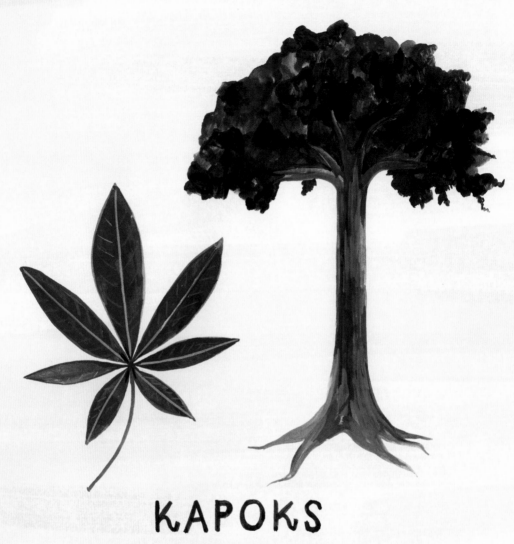

KAPOKS

Kapoks (*Ceiba pentandra*) are found throughout South America and central Africa. Sometimes called ceiba or ceibo, these trees were sacred to the ancient Maya. They remain venerated throughout their range even as they are threatened by deforestation. The kapok's tall trunks are covered in spikes and buttressed at the roots, and their crowns can reach widths rivaling their heights of up to 200 feet (60 m). They bear leathery fruit pods that, when split, release soft, fluffy fibers that can be used as an alternative to down fillers and to make paper and fabric. Other trees of the genus *Ceiba*—like the pochote (*Ceiba aesculifolia*) of Central America and the silk floss tree (*Ceiba speciosa*) of Brazil and Argentina—release similar fibers.

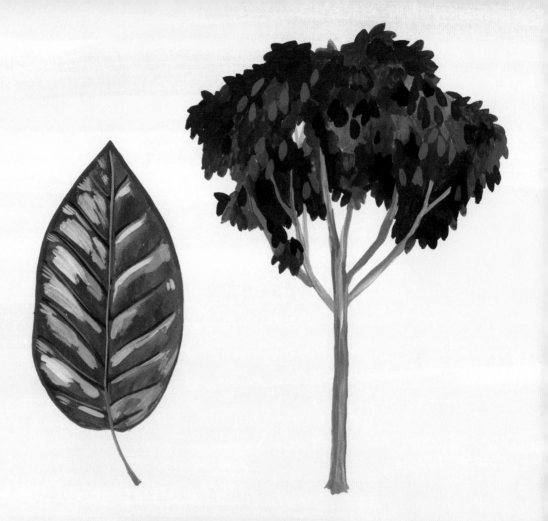

CINCHONA

Humans have found ways to use thousands of tree species for therapeutic purposes, but the cinchona (*Cinchona officinalis*) has had perhaps the most widespread impact in fighting disease: it's the original source of malaria-fighting quinine. This evergreen tree grows in humid lowland forests in Ecuador and Peru, where it can reach heights of 33 feet (10 m). Quechua people have long used cinchona medicinally, and it became the go-to treatment for malaria around the world until anti-malarials were synthesized in the twentieth century. Because certain strains of malaria have developed resistance to those drugs, natural quinine is still some-times used as a treatment, so the cinchona continues to be an important medical resource.

TEMPERATE TREES

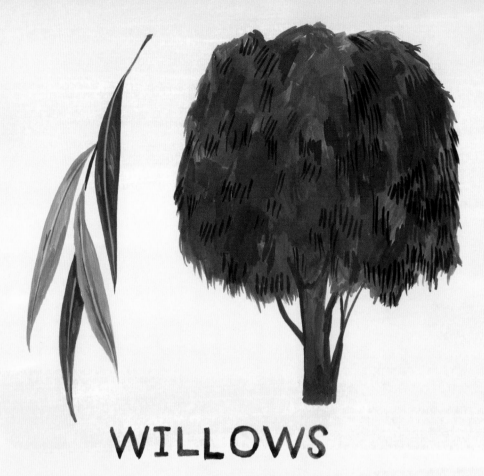

WILLOWS

Hundreds of species of willow (genus *Salix*) grow all over the world, though most are more shrub- or reed-like than tree-formed. Indeed, willows in general tend to bend the category of tree since they commonly grow with multiple trunks, and trees are often defined by a single woody stem. Willows can be propagated from a single cut twig.

Take note of the genus name *Salix*: willow bark contains salicylic acid, a precursor to modern aspirin that is known for its anti-inflammatory properties. In addition to being used for their medicinal applications, willow trees have long been coppiced and pollarded to produce both shoots to feed livestock and also long, flexible rods for traditional crafting. These are used in wickerwork and other weaving and even to create the woven component of traditionally constructed wattle-and-daub walls. A common modern application of willows is as a green-minded solution for water purification: they can be planted in polluted areas to clean and recycle dirty water runoff.

The weeping willow (*Salix babylonica*), with its elegantly draping branches, may be the best-known (or, at least, the most charismatic) of willows. It likes to grow near water, arcing over the edge of lakes and rivers. Its form and name have led to an association with mourning. The corkscrew or dragon's claw willow (*Salix matsudana* 'Tortuosa'), first cultivated in China, is planted ornamentally and grows vigorously. Every bit of the tree is curly, from its branches to its twisty twigs and leaves. So-called pussy willows are not a species but a life stage of several different kinds of willows—as they flower, their catkins present with a downy gray fuzz. These symbolize springtime in many cultures and are used ceremonially and decoratively around the world to celebrate growth and change, such as at Easter and Lunar New Year.

WEEPING WILLOW

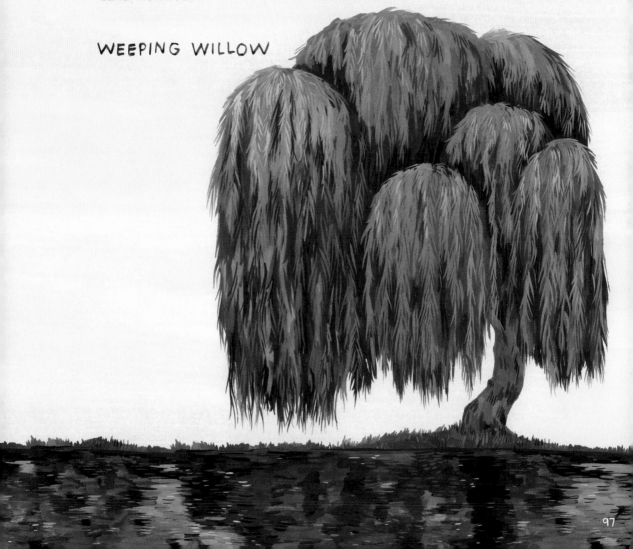

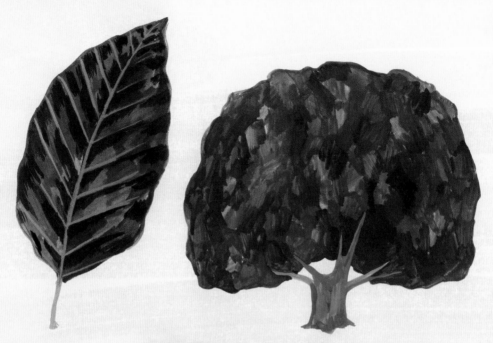

BEECHES

The small genus *Fagus* has ten species of smooth-barked gray trees that can grow to 130 feet (40 m) tall. They yield hard, durable timber that is often used to make furniture and tools. Their nuts, once more widely consumed by humans, remain an important source of food for wildlife. A possibly erroneous but commonly cited etymology posits that the word for "book" comes from the same Germanic and Anglo-Saxon roots for "beech" and that some of the earliest European books were written on boards of beech.

One variety of European beech (*Fagus sylvatica*), called the copper beech ('Purpurea'), bears purple-red leaves in place of the usual green. Another, called the weeping beech ('Pendula'), has weeping branches that are every bit as dramatic as those of the weeping willow. Still another, Dawyck beech ('Dawyck'), grows straight up like a witch's broom jammed handle-first into the ground.

A Magellan's beech (*Nothofagus betuloides*) on Chile's Isla Hornos at the very tip of South America is recorded as the southernmost tree on the planet (though as Earth continues to warm, trees are likely to spread farther south in the future).

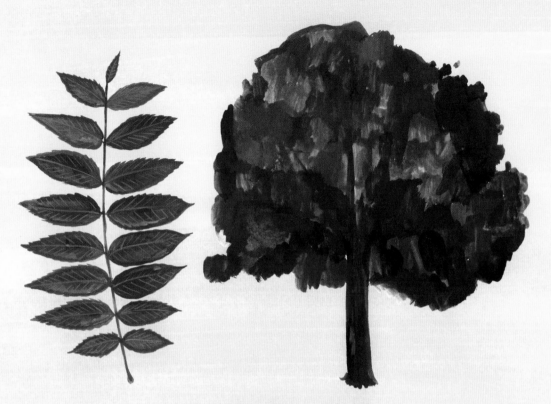

WALNUTS

The walnut family is called Juglandaceae and encompasses around seventy species of tree, many of which provide commonly consumed nuts. Slow to grow, black walnuts (*Juglans nigra*) have aromatic leaves and rich, edible seeds contained inside hard nutshells, themselves encased in a husk of fragrant green fruit. From the husks and fruit, dark dyes and inks can be brewed. Juglone, the compound that produces these colorants, is toxic to other plants, and walnuts are therefore frequently found with only sparse plant life in their vicinity. A related tree is the butternut (*Juglans cinerea*, also called the white walnut), a medium-size tree that is often found growing in clumps where caches of nuts had been stashed by squirrels. Hickories (genus *Carya*) belong to the same family as walnuts. Some hickory nuts are eaten by humans, the most common of which is the pecan (*Carya illinoensis*). Another edible hickory nut comes from the shagbark hickory (*Carya ovata*), mature specimens of which are covered in curling strips of bark that peel all but completely off the trunk.

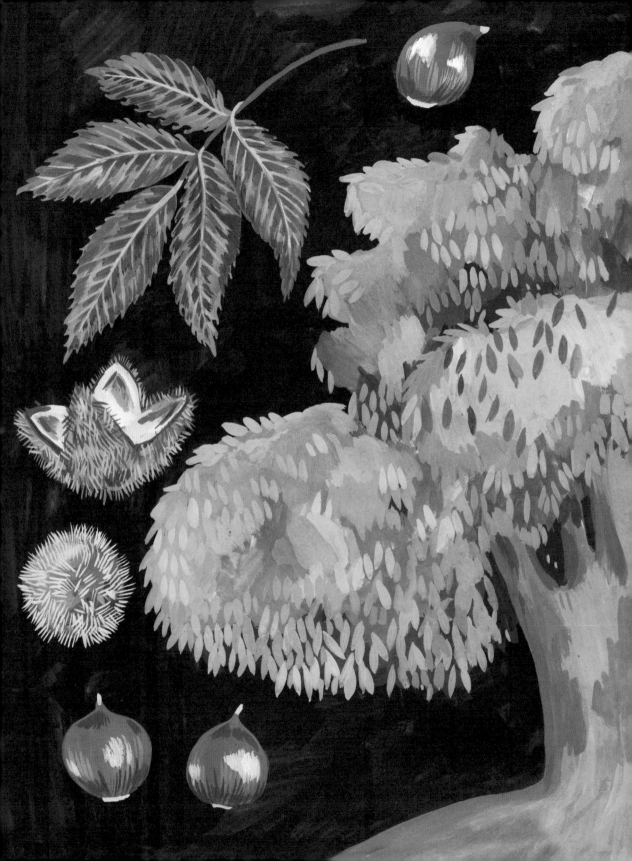

AMERICAN CHESTNUT

As humans have moved over the Earth, we've inadvertently brought blights and invasive species with us, creating ripple effects in ecosystems around the planet. The majestic American chestnut (*Castanea dentata*) dominated eastern North America until late-nineteenth-century trade accidentally introduced it to a blight that spread across the continent. In the span of a few decades, an estimated 4 billion trees were destroyed. Once highly valued for its timber and prized for its edible nuts, the tree is now function-ally extinct. Even now, when existing root stocks send sprouts up out of the ground, the blight still locates and kills them.

But as grim as the story of the American chestnut is, hope for its resurrection persists: tree lovers have not given up on rescuing this tree from extinction. Botanists continue to cultivate chestnuts, planting and observing the trees until the blight eventually finds them again. The chestnut hasn't given up either; the Sierra Club estimates that 430 million saplings continue to grow in North America. Hybridization efforts are also on the horizon. It's possible that, thanks to the tenacity of the chestnut and the humans who want to reverse the damage done, someday hybridized American chestnuts could tower over the landscape once more.

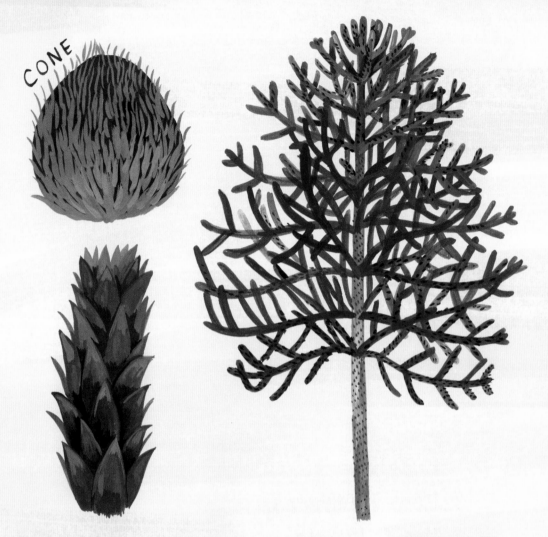

CONE

MONKEY PUZZLE TREE

The monkey puzzle tree (*Araucaria araucana*) is an evergreen conifer found in Chile and Argentina. Its name refers to its spiny branches, which would indeed be a puzzle for even a monkey to climb. The name was likely coined by someone who, seeing a cultivated specimen in an English garden, perhaps did not realize that no monkeys live in the tree's native habitat. Bladelike leaves shingle the tree's branches; the bark, spiny in its youth, grows in folds and whorls over the scars of fallen lower branches. The large seeds found in its cones are commonly eaten raw, used in cooking, or fermented into beverages.

WOLLEMI PINE

Millions of years ago, forests of a certain prehistoric tree with fernlike fronds grew across Australia, New Zealand, and Antarctica. Contemporary scientists believed that the species had gone extinct 2 million years ago. Then, in 1994, it was found in a remote area of Australia's Wollemi National Park. Scientists were able to match it to fossilized prehistoric pollen samples, demonstrating that the tree—given the common name of Wollemi pine—was virtually unchanged compared to its prehistoric counterparts.

Despite its common name, the species *Wollemia nobilis* is not technically a pine but a member of the ancient conifer family Araucariaceae. Its genus name, *Wollemia*, comes from the park where it was found, which in turn gets its name from the Aboriginal word *wollumii* for "look around you" or "watch your step," referencing the park's sandstone cliffs. The Wollemi pine likely persisted through the millennia partly due to its isolation in a practically inaccessible area of canyons, away from the reaches of human interference. Because its discovery and subsequent publicity were likely to bring on a stream of unwelcome human visitors, posing risks related to trampling, soil compaction, and more, the location of the wild Wollemi pines was kept secret and is now under strict protections. During wildfires in 2020, specialized firefighters defended the fewer than two hundred wild specimens from the blaze, and botanists around the world are propagating the trees and growing them in gardens to keep this species alive.

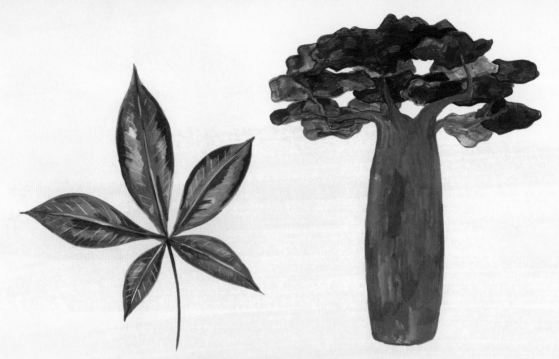

BAOBABS

Baobabs (genus *Adansonia*), native to tropical and temperate parts of Africa and Australia, look like they might have come from another world. Their branches are shaped more like roots, giving them the nickname "the upside-down tree." Their trunks, with circumferences up to 100 feet (30 m), are unusually large in proportion to their height and crown size. While baobabs do grow to enormous size, they can also shrink. This is due to their ability to store water—up to 26,400 gallons (120 kl) at a time. It's stashed within their massive, spongy trunks and used it as needed over time. The trees swell and shrink depending on how much water they retain. They're sometimes likened to elephants in their appearance—as it happens, where baobabs and elephants coexist, elephants do sometimes rip the trees apart to get to the moisture within.

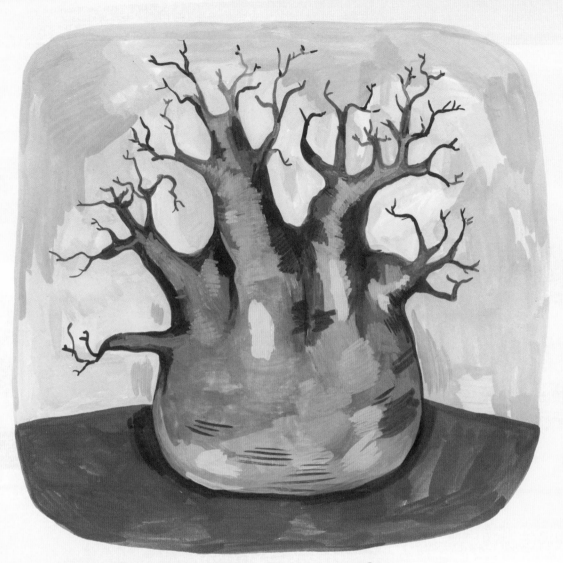

A SWOLLEN BAOBAB

Baobabs tend to turn hollow over time. Since they are so enormous, larger trees with the most spacious interiors inevitably attract humans, who have gone so far as to build an entire pub inside a trunk. The stature of baobabs alone demands respect, but so does their age—they can live to be thousands of years old, a life span among the longest of any other flowering plants on Earth. *Reniala*, the Malagasy name for Madagascar's endemic baobab *Adansonia grandidieri*, translates to "mother of the forest."

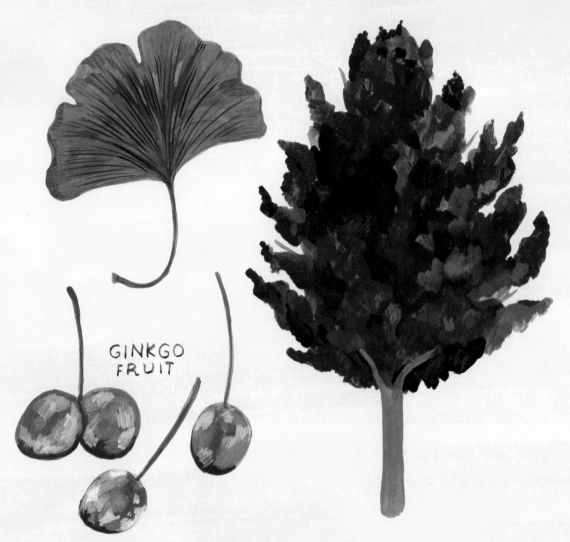

GINKGO
FRUIT

GINKGO

The ginkgo tree (*Ginkgo biloba*) is often called a living fossil—a poetic way to say that a species hasn't changed in a long time. It's the last living species in the order Ginkgoales, a group that originated in what is now China and flourished in the Jurassic Period. It has a propensity for tolerating pollution and is therefore enjoying a renaissance in cities around the world, where it can thrive even in confined roadside plantings. This is often to the dismay of nearby residents, since the female ginkgo drops fruit that is pungent on its best day and quickly turns foul-smelling on the sidewalk.

The leaves of the ginkgo provide another of its common names, the maidenhair tree, since they grow in the same shape as the leaves of the maidenhair fern (a shape evoking a head of long hair). The leaves are unique among trees not only for their shape but for their synchronized leaf drop. While most other trees form scar tissue between their twigs and leaves at different times for individual leaves throughout their crown, ginkgoes form this tissue—and therefore drop their leaves—all at once, laying a shimmering yellow blanket on the ground beneath a naked tree.

OAKS

Oaks (genus *Quercus*) are sturdy. With their ability to withstand storms and fire, along with their general air of stoicism, they have come to symbolize wisdom and steadfastness. There are nearly six hundred species of oak around the world. They are shapeshifters: they can live among other trees in forests, where they compete for canopy space by growing tall bare trunks, but they also thrive as lone sentinels on the prairie, where they spread and stretch their limbs, practically lolling in the sun. Cork oak (*Quercus suber*) provides the cork for wine-bottle stoppers; the bark can be harvested every decade or so and is stripped off in enormous sleeves, leaving a naked red-brown trunk behind. So-called live oaks include any number of oak species, such as the coast live oak (*Quercus agrifolia*), that stay evergreen throughout the year. The northern red oak (*Quercus rubra*) is deciduous and rivals sugar maples with its brilliant fall color.

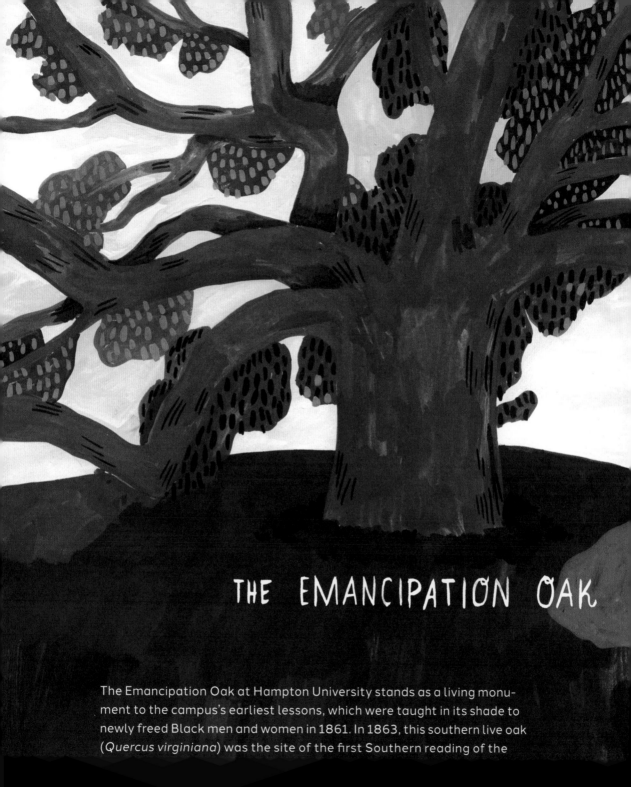

THE EMANCIPATION OAK

The Emancipation Oak at Hampton University stands as a living monument to the campus's earliest lessons, which were taught in its shade to newly freed Black men and women in 1861. In 1863, this southern live oak (*Quercus virginiana*) was the site of the first Southern reading of the

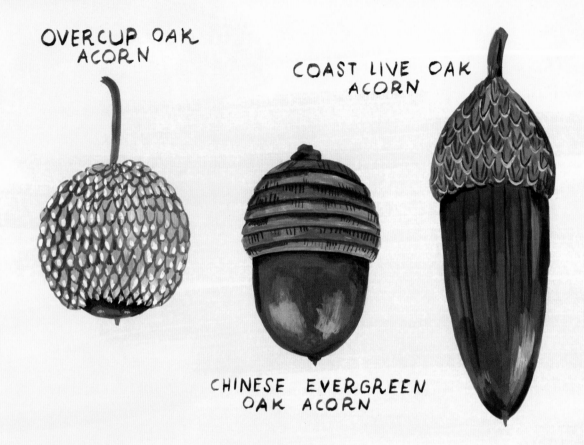

OVERCUP OAK ACORN

COAST LIVE OAK ACORN

CHINESE EVERGREEN OAK ACORN

The acorn is the hallmark of the oak. These little nuts vary in appearance from one to the next of this genus's hundreds of species. The overcup oak (*Quercus lyrata*) has a cap that nearly covers the entire nut; the Chinese evergreen oak (*Quercus myrsinifolia*) has a striped cap; the coast live oak (*Quercus agrifolia*) has a long thin acorn. The collective term for the acorns that fall in a given season is *mast*; oaks are known to produce variable quantities of acorns from year to year, with periodic boom years known as mast years. These are observed not only in individual trees but also in groups of trees, as when the oaks in a particular town collectively experience a mast year and carpet the ground with acorns. At one time, human consumption of acorns was commonplace, and some cultures continue to eat them (they require significant culinary preparation, since they are very high in bitter tannins). The acorn woodpecker is named for its enterprising food storage strategy: it creates a granary tree in which it drills up to 50,000 holes, caching an acorn inside each one.

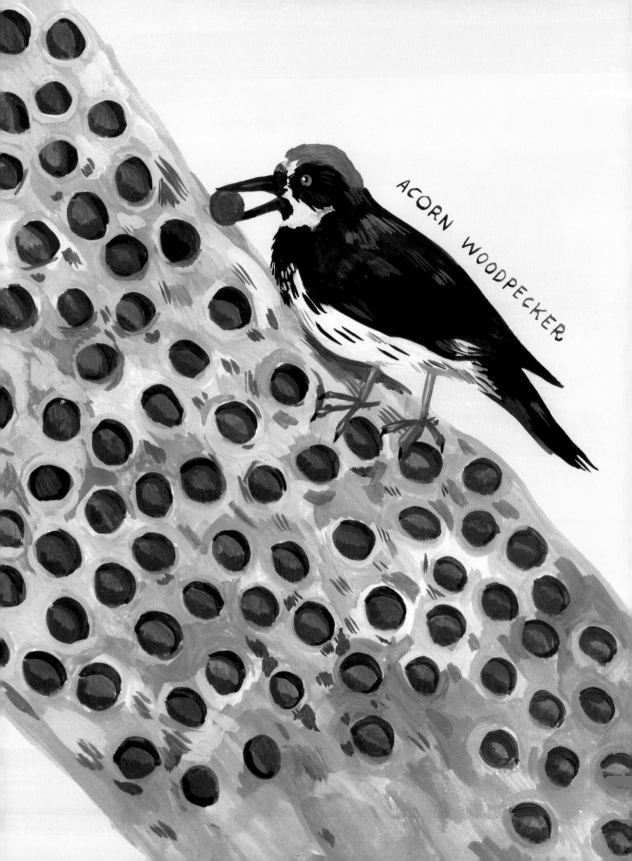

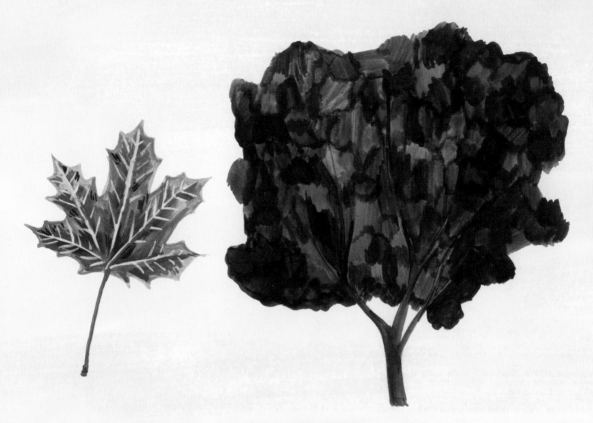

MAPLES

Maples (genus *Acer*) are beloved for their deciduous foliage; in most species the leaves are distinctively palmate. They also exhibit some of the most dramatic examples of color change in autumn leaves, with some of the brightest reds, oranges, and yellows found in any landscape. This genus of more than one hundred species includes the box elder (*Acer negundo*), Japanese maple (*Acer palmatum*), Amur maple (*Acer japonicum*), sugar maple (*Acer saccharum*), and red maple (*Acer rubrum*).

Maple sap can be boiled down to make maple syrup. Sugar maples are the most common source of sap for this purpose—their sap must be reduced by a factor of around forty times—in other words, 40 gallons (151 L) of sugar maple sap boil down to about 1 gallon (3.8 L) of maple syrup. Other trees, like box elders and even birches, can be tapped for syruping, too, though the sap they yield needs to be boiled down even further.

SAPSUCKER SAPWELLS
IN A TREE TRUNK

Humans aren't the only animals who make good use of abundant tree sap: sapsuckers use their beaks to drill grids of holes in tree bark, releasing the sap for them to eat. The sugary wells opened by the sapsuckers also draw opportunists such as hummingbirds, bats, and porcupines.

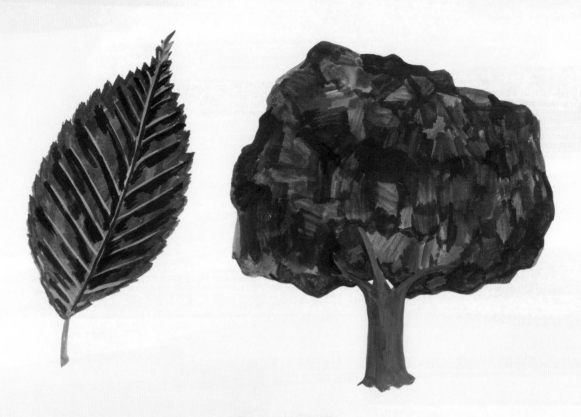

ELMS

There are around thirty species of elm (genus *Ulmus*) that grow across the temperate regions of the Northern Hemisphere. As their wood was once commonly used to build coffins, elms are associated with death, so it is bitterly ironic that the elm has suffered from its own battles with premature death. Dutch elm disease, an epidemic caused by the fungus *Ophiostoma novo-ulmi*, has ravaged the American elm (*Ulmus americana*) and other vulnerable elm populations around the world. These trees do not grow as widely as they once did, and large, mature individuals are rare. Efforts are underway to create new elm varieties that can thrive in the face of Dutch elm disease, including hybridization with disease-resistant species such as the Siberian elm (*Ulmus pumila*). When healthy, the tallest of these trees can reach well over 150 feet (46 m). Some wild food foragers report that the Siberian elm's samaras—their winged seeds—are delicious when eaten fresh or dried and processed.

ELM SAMARAS

POPLARS

The wood of poplar trees (genus *Populus*) has a long history of human use. It was supposedly a common choice for light but durable ancient shields. The *Mona Lisa* is painted on a panel made from poplar wood. Neanderthal remains from 50,000 years ago show evidence of poplar wood in their teeth; they chewed it for pain relief since it contains the same salicylic acid of the related willow tree. The aspens—*Populus tremuloides*, the quaking aspen; *Populus grandidentata*, the bigtooth aspen, and others—belong to this genus and are lauded for their bright fall foliage and the seemingly constant shimmering of their leaves in the slightest breeze. (Folklore says the aspen tree has excellent hearing and trembles in response to the sounds it hears from all over the world.) Several different species known as cottonwoods (*Populus trichocarpa*, the black cottonwood; *Populus angustifolia*, the narrowleaf cottonwood; and others) belong to this genus, too; they are collectively known for unleashing faux snowfalls of fluffy white seed bodies in spring. Since poplars grow quickly, they are commonly used in manufacturing and often made into plywood, pallets, matches, paper, and more. Stands are also often planted on farms, where they provide quick and effective windbreaks on otherwise treeless land.

POPLAR STAND

CYPRESSES

The cypress family (Cupressaceae) includes junipers, arborvitae, incense cedar, the redwoods, giant sequoias, and various other cypress species. The name *arborvitae* (genus *Thuja*) means "tree of life," attributable either to its purported medicinal properties or perhaps its evergreen, always alive foliage. Arborvitae are often planted as ornamentals and used in hedges. The genus includes white cedar (*Thuja occidentalis*), which may have been the first North American tree brought to Europe, and western red cedar (*Thuja plicata*), which can live for over a thousand years and in the Pacific Northwest is used by Indigenous people to make traditional dugout canoes.

Bald cypress (*Taxodium distichum*) is known for its extremely rot-resistant wood—its roots can remain submerged in water for months at a time. It pushes bumpy knees up out of the water; their purpose is a matter of debate (common theories are that they stabilize the tree or aid in gas exchange). The cypress knees also form wide buttress roots at their base.

JOMON SUGI

Jomon Sugi is an individual of the cypress genus *Cryptomeria* located on Yakushima Island in Japan. It is often cited as one of the country's—if not the world's—oldest trees, thought to be thousands of years old.

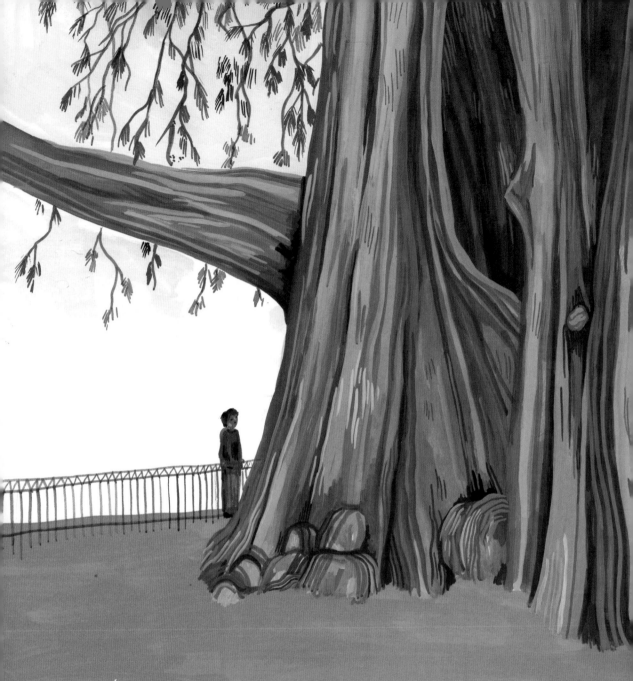

El Árbol del Tule (the Tule Tree), a Montezuma cypress (*Taxodium mucronatum*) in Mexico, is thought to be the stoutest tree in the world—that is, the tree with the largest diameter trunk, measurements of which range from of 30 to 38 feet (9 to 12 m) depending on the measuring method (because the trunk is so heavily and unevenly buttressed, measuring it can prove a bit unwieldy).

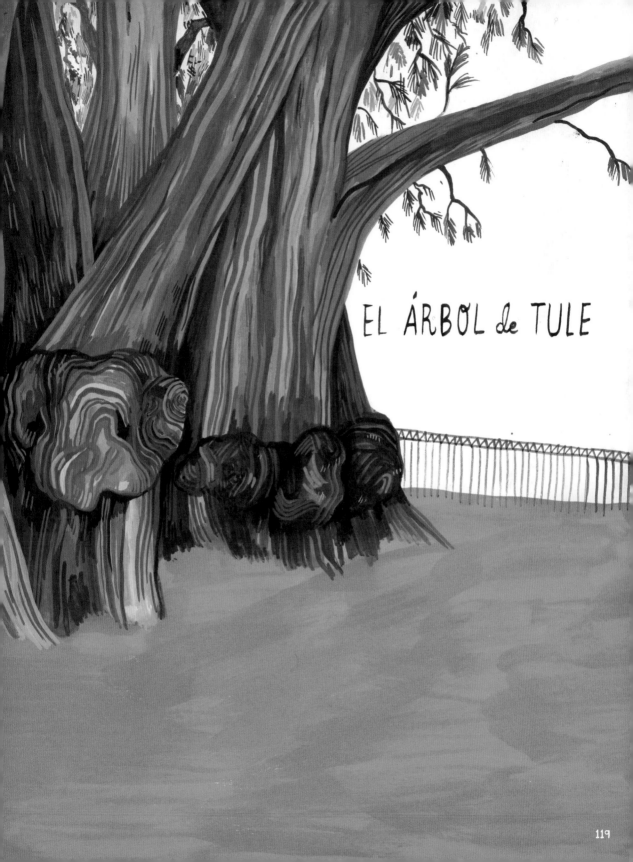

EL ÁRBOL de TULE

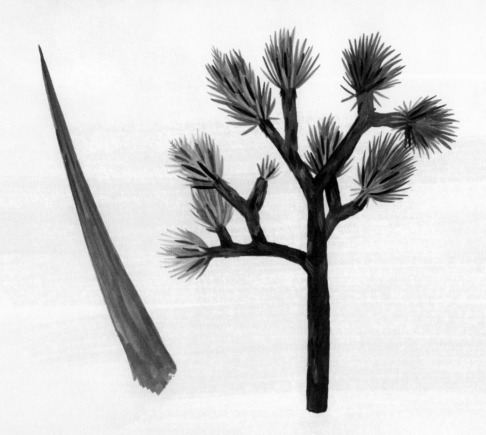

JOSHUA TREE

The namesake of Joshua Tree National Park, the Joshua tree (*Yucca brevifolia*) is a type of yucca, a spiky desert plant native to the Americas. Its adaptations to dry desert living include limited leaf growth (and therefore limited water loss via transpiration) and a waxy coating on the leaves. The distinctively shaped tree, which grows to heights of 48 feet (15 m) and whose native Chuilla name is *hunuvat chiy'a* or *humwichawa*, has long been used by local Indigenous people as a crafting material—woven into baskets and sandals—and as a food source. By the twentieth century, the biblically influenced name Joshua tree—which originated with Mormon settler-colonizers—had entered common usage.

Because this tree is a monocot, it does not grow in growth rings (a trait it shares with palms), so its age can be estimated only by its height: it's known to grow 0.5 to 3 inches (1.3 to 7.6 cm) per year. By this measure, some Joshua trees may be close to a thousand years old.

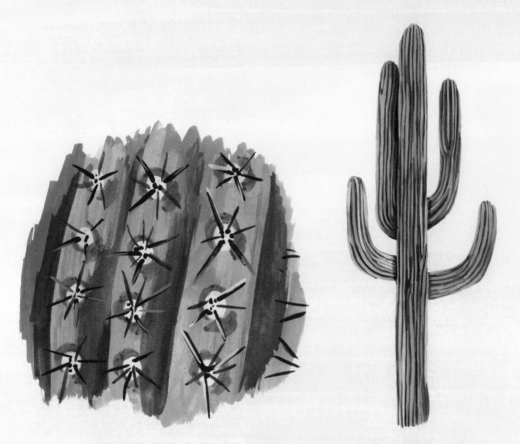

SAGUARO CACTUS

As a cactus, the saguaro (*Carnegiea gigantea*) doesn't have leaves, but it does have a large woody trunk, and it easily fills the niche in an ecosystem with few other trees. It even yields lumber, of a kind: the woody ribs of the cactus, which are left behind once the flesh decays, were once used widely as a traditional building material in everything from fences to furniture. The oldest saguaros can reach 50 feet (15 m) in height and live up to two hundred years.

CACTUS
RIBS

APPLES

Apple trees (genus *Malus*) produce one of the most commonly eaten fruits worldwide, and humans have ascribed to them connotations of love, fertility, and destiny. The forbidden fruit in the biblical tale of the Garden of Eden is commonly depicted as an apple, though the original story referred to only an unspecified generic fruit. Golden apples appear throughout Greek mythology (though these, too, may not necessarily be literal apples, but any number of different fleshy, seeded fruits). Then there are fortune-telling games and folk spells: toss an apple peel over your shoulder and it will land in the shape of your future spouse's initial; bury or burn apples to make someone fall in love with you. Early Roman naturalist Pliny the Elder came to the far-fetched conclusion that hedgehogs rolled around on fallen apples to spear them on their spines and carry them back to their burrows to prepare for winter.

Apple trees and other fruit trees are planted so widely in cities and towns that the fruit they bear often goes to waste, even after enthusiastic wildlife has a go at it. (Based on the abundance of fruit on ornamental trees, which can hang on through wintertime, ornithologist David Allen Sibley notes that a number of bird species that used to be migratory are now likely year-round residents.) Community projects have begun

springing up around the world to connect would-be gleaners with home- and landowners whose trees produce more than they can use. Those who own the trees are saved from piles of fly-ridden, rotten fruit in their yards, and those who gather the fruit are able to enjoy or distribute it throughout the community. What a way to eat!

The taxonomic family Rosaceae is home not just to apples but also to roses and many of the edible fruits that humans cultivate today, like raspberries, strawberries, and tree-borne fruits such as apricots, peaches, pears, plums, and cherries.

To combine the vigor of one plant with the fruit of another, orchardists use grafting, which involves cutting portions of a desired growth plant and inserting them into an incision on a vigorous host plant. Grafting allows orchardists to customize varietal selection, disease resistance, size, and more. Apples don't grow "true to seed"—that is, a tree grown from the seed of a parent tree would yield completely different fruit—so apple trees, in particular, are almost always grafted.

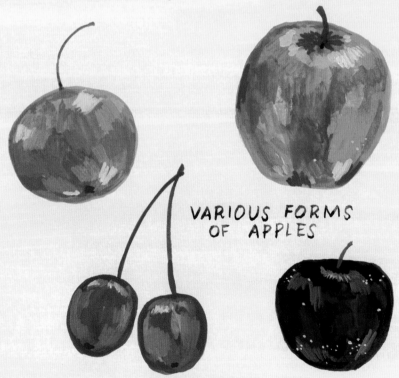

VARIOUS FORMS
OF APPLES

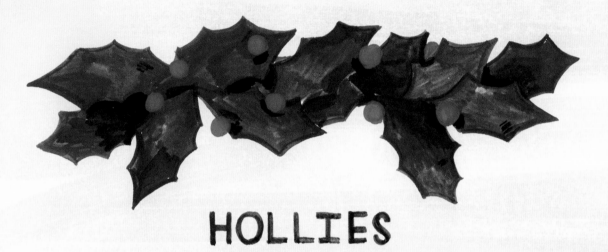

HOLLIES

There are hundreds of species of holly (genus *Ilex*), the most recognizable being the common holly (*Ilex aquifolium*), an evergreen broadleaf tree with dense, often spiny foliage and shiny, hard red berries. Many varieties of this species exist, with leaves ranging from solid green to variegated with white and yellow, and leaf edges from extremely spiny to completely smooth. It's long been a popular Christmas decoration and is believed to have played a role in popularizing red and green as the colors of Christmas. Hollies were once thought to ward off magic if planted as sentinels on one's property. A relative of the common holly is yerba mate (*Ilex paraquariensis*), whose leaves are used to brew the traditional caffeinated South American drink known as mate.

LOCUSTS

Native to North America, locust trees (genus *Robinia*) fall under the family Fabaceae—the legumes—alongside acacia trees as well as edible non-tree species, like beans and lentils. The leaves of the black locust (*Robinia pseudoacacia*) are pinnately compound, with round lobey leaflets reminiscent of the true acacias. The black locust's flowers look as though they'd be more at home on a sweet-pea vine than on a tree, and its fruit grows in bean pods. Its aromatic flowers are sometimes eaten fresh or cooked. Another legume from a related genus is the Kentucky coffeetree (*Gymnocladus dioica*). Its seeds are toxic when raw, but can be roasted and brewed to make a coffee-like drink (though it is reportedly a poor substitute for the real thing).

PLANE TREES

Plane trees (genus *Platanus*) are recognizable by their scaly bark, palmate leaves, and pom-pom-like seed balls. One variety, the hybrid London plane (*Platanus* x *acerifolia*), is particularly tolerant of vigorous pruning, root compaction, and air pollution, so it thrives in urban areas—it's believed that more than half the trees in London are London planes.

Plane trees are sometimes called sycamores. This name crops up around the world in common names for unrelated species with plane tree–like characteristics. Other sycamores include the unrelated sycamore maple (*Acer pseudoplatanus*), which shares the plane tree's palmate leaf shape; the silver sycamore (*Litsea reticulata*), whose bark flakes off in scaly patches like the plane tree's; and the sycamore fig (*Ficus sycomorus*).

ASHES

Ash trees (genus *Fraxinus*) have pinnately compound leaves that are particularly recognizable. Their wood is hard, strong, and flexible, so it's often used for making wooden handles, oars, and other bent pieces. Certain species of ash have a property that makes them perfect for basketmaking—they literally split into strips. The black ash (*Fraxinus nigra*), which grows in swampland and near water, is one such species. This tree can be felled, pounded with a mallet, and delaminated, meaning the cylinders of wood are pulled apart in long strips that can be trimmed, cut, and used to weave traditional baskets. The emerald ash borer, a beetle whose larvae tunnel in ash trees, is a major threat to ash trees in North America—a cause of special concern, as ash trees are considered sacred to many Indigenous people who share their range.

Yggdrasil, the world tree of Norse mythology, is often described as an ash tree (though some argue this is a mistranslation and that the tree is actually a yew). This magical tree connected the nine worlds of Norse myth. The tree was a source of protection and wisdom; its fruit was said to ensure safety in childbirth, and Odin, the king of the gods, once sacrificed himself on the tree to gain knowledge.

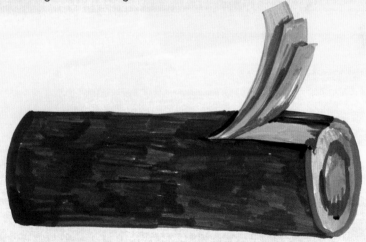

DELAMINATING ASH LOG

HAZELS

There are around twelve species of hazels in the genus *Corylus*, many of which have shrublike growth patterns, though some are treelike and can reach reasonably large proportions. The Turkish hazel (*Corylus colurna*) is the tallest, growing up to 70 feet (21 m). Hazel has long been the wood of choice for the construction of witching rods, the Y-shaped, handheld devices used in the practice of dowsing, a pseudoscientific method of locating water or minerals underground (a witching rod is thought to be pulled by supernatural forces toward the desired subject). Hazelnuts, sometimes called filberts, grow in a variety of curious husk shapes across species, some of which produce the popular edible nuts.

this side points to treasure

hold here

DOGWOODS

Taking the form of shrubs and small trees, dogwoods (genus *Cornus*) are often part of the understory of the forest rather than the large pillars of its leafy cathedrals. Still, some dogwood varieties are ornamental favorites. Kousa dogwood (*Cornus kousa*) bears a galaxy of little white starburst flowers against its deep-green foliage. The wedding cake tree (*Cornus controversa* 'Variegata') sends out branches in tidy tiers and ices itself with white flowers and white borders on each green leaf.

YEWS

Yews (genus *Taxus*) have a unique configuration; though their leaves are needlelike, as in most conifers, they do not bear cones or have resin canals. They have subsequently been the subject of taxonomic disagreement, not just as to whether yews qualify as conifers but also as to how many species of yew there are—some say up to ten, others say just one, with multiple subspecies.

Yews are known for being highly poisonous to people, livestock, and other animals. The seeds are covered in deceptively alluring bright red berries. The flesh of the berries is not poisonous, but the seed inside is exceedingly so; some birds eat the flesh and expel the seeds, but for other animals any consumption can prove fatal. Yews are often found in churchyards, in part because they are believed to be sacred—but also due to their poisonous nature, as a deterrent to farmers who might otherwise let their livestock browse on free graveyard grass.

The trees are difficult to accurately age because they tend to go hollow over time, denying any chance of an accurate ring count of their trunks and branches. Still, many old yews are venerated, particularly those across the churchyards of England; the long life spans of some are variously claimed to be 1,000 to 4,000 years (though not without dispute).

THE FLORENCE COURT YEW

The moss-covered Florence Court Yew in Ireland is around 250 years old and the oldest of a variety called the Irish yew (*Taxus baccata* 'Fastigiata'). Since it is female, this "mother of all Irish yews" can be reproduced only via cuttings. And since it was one of only two individuals of this particular variety, and the only one that remained alive after 1865, it's believed that all the Irish yews on Earth (the tree's keepers estimate there are millions) are descendants of this very tree.

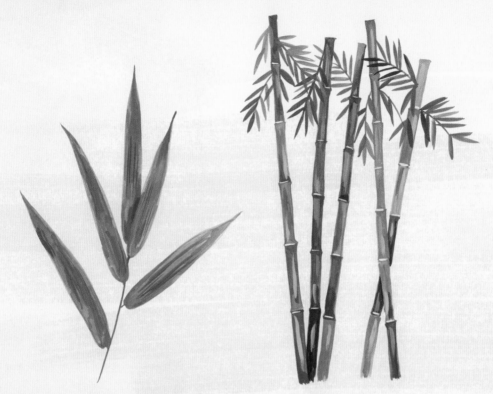

BAMBOO

Though scientifically classified as a type of grass, the bamboo subfamily Bambusoideae contains a number of species that produce truly substantial woody stem growth and great height. The tallest bamboo forests can top out around 100 feet (30 m). Due to its breakneck growth speed—some varieties can add more than 24 inches (60 cm) of height in a single day—bamboo has become a popular material for consumer products all over the globe, and its purported ability to sequester carbon while providing cheap and copious raw material is lauded (though some question the claims of its carbon-capturing abilities).

The giant pandas of China's temperate mountain bamboo forests are notorious for subsisting on bamboo leaves, stems, and shoots. Strenuous conservation efforts, including measures to expand protected bamboo forests as reserves, have moved this charismatic conservation icon up from the Endangered to the Vulnerable category, with an estimated 1,864 individuals currently living in the wild.

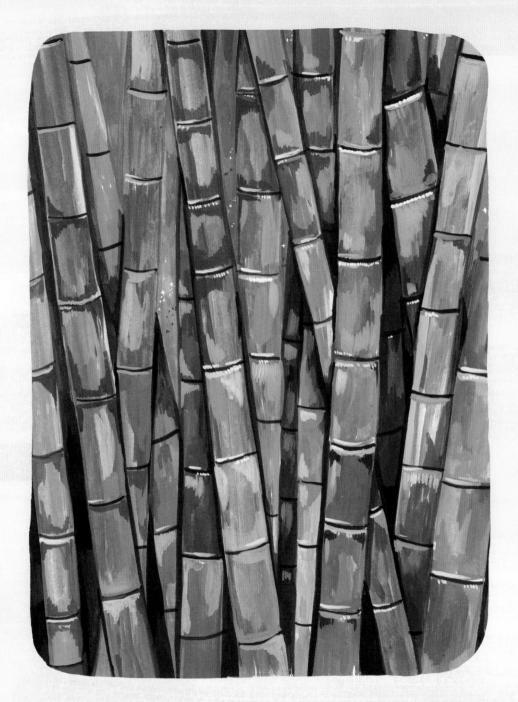

Kyoto, Japan, is home to the Sagano Bamboo Forest, a popular tourist destination. The grove is recognized for the rustling, creaking, and clacking it makes as the wind blows through its canes.

BOREAL TREES

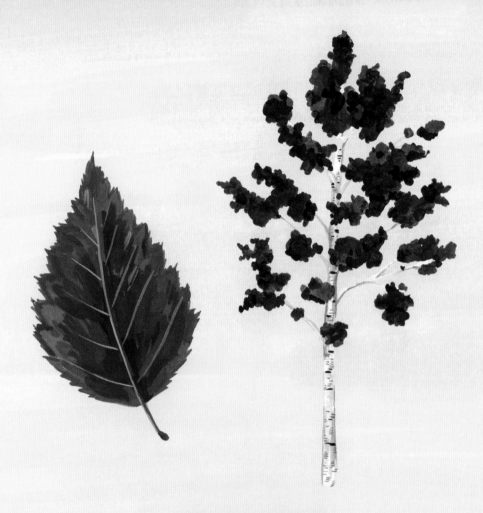

BIRCHES

Around sixty species of birch in the genus *Betula* grow across temperate and boreal regions of the world. Some are so small as to be considered shrubs, while others can reach 80 feet (24 m) or more in height. These broadleaf deciduous trees bear catkins and are best known for their bark. Paper birch (*Betula papyrifera*) in particular is a prized source of material for traditional craftspeople in many northern cultures. Its buttery-soft bark can be harvested easily if the timing is right, and often this can be done without damaging the tree. The paper bark provides a pliable, durable, and beautiful material for crafting objects ranging from shoes and bags to canoes. Chaga (*Inonotus obliquus*), a parasitic fungus that grows on birch trees, looks like lumps of coal and may have medicinal properties.

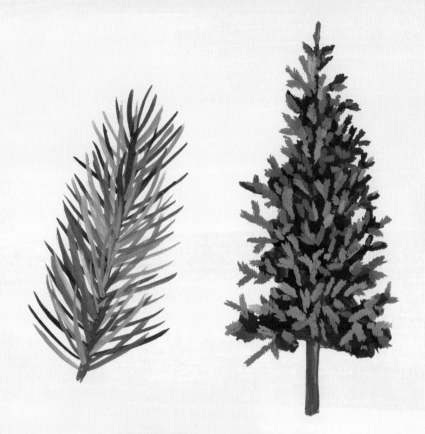

SPRUCES

The genus *Picea* contains some forty species of spruce that grow in the colder parts of the world. Spruces have single needles, usually very prickly and pointed; after each falls, it leaves behind an elevated bump on the twig. This can help distinguish them from firs, since firs have smooth twigs. (Spruce cones also hang down from the branch rather than projecting upward, as do fir cones.) Sitka spruce (*Picea sitchensis*) is the largest spruce in North America, regularly growing to well over 100 feet (30 m) tall, but capable of reaching heights of more than 300 feet (91 m). It is commonly cultivated in plantations for its timber. The blue spruce (*Picea pungens*) is named for the characteristic blue cast to its needles. Spruce tips, the soft new growth that sprouts from the branch ends in springtime, are edible and considered a delicacy by some foragers.

SPRUCE TIPS

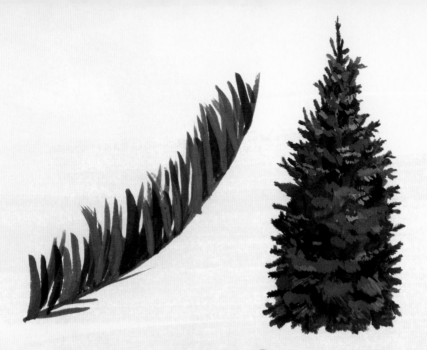

FIRS

The word *fir* (like *pine*) is sometimes used to describe any coniferous tree, but the genus *Abies* is the taxonomic home of the true firs. The genus comprises around fifty species growing across the Northern Hemisphere in a range of sizes. Fir branches tend to project straight outward or up rather than drooping. Their cones don't dangle, but instead project directly upward from their branches, and they disintegrate from their tops down as the seeds are released. In some species, the immature cones are purple or blue, as in the Korean fir (*Abies koreana*).

Firs have an air of wintry magic, and many species are named with reverence, such as the sacred fir (*Abies religiosa*), noble fir (*Abies procera*), and grand fir (*Abies grandis*). It seems fitting, then, that firs often are selected and brought into homes as symbols of Christmas and midwinter. To that end, balsam fir (*Abies balsamea*) is known for its aromatic sap. Fraser fir (*Abies fraseri*), which hangs on to its short needles even after being cut and has nicely taut branches, is a popular Christmas tree.

PURPLE-BLUE CONES
OF THE KOREAN FIR

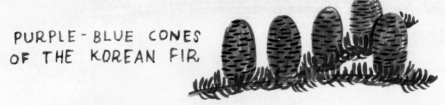

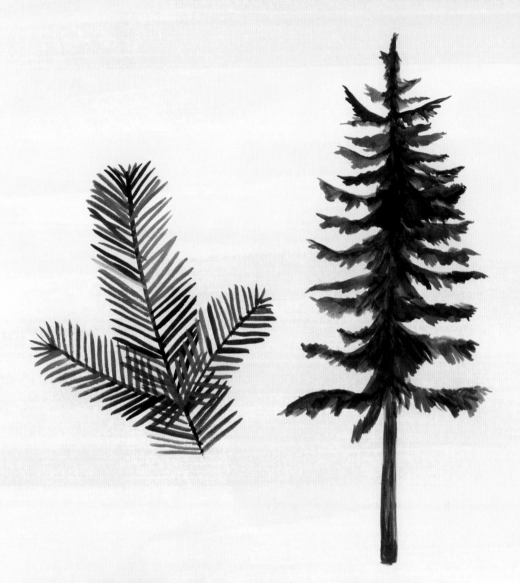

DOUGLAS-FIRS

Douglas-firs are not true firs and belong in a separate genus, *Pseudotsuga*. They can grow to 295 feet (90 m) when left untouched. They are considered among the most important sources of timber in North America. A Pacific Northwest legend tells of the Douglas-fir offering shelter to mice during a forest fire: the little mice scurried up the tree's trunk and hid inside the tree's cones, and their tails are still visible as the fringy bracts peeking out from between the scales (see the female cone on page 31).

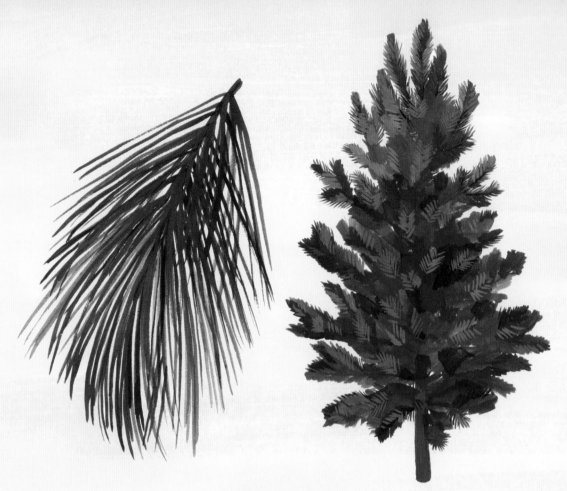

PINES

Like many other boreal trees, pines (genus *Pinus*) are not restricted to the boreal zone—there are more than a hundred species of pines around the world—but even when found in more temperate areas, their appearance does evoke a sense of the north. Like all evergreen trees, pine trees tend to be associated with immortality and tenacity for their ability to stay green and hold on to their needles. Like firs, pines are associated with winter festivals, and several pine species are popular Christmas trees. In the Shinto religion, pines are placed on either side of entryways as *kadomatsu*, or gate pines, believed to welcome and provide shelter for ancestral spirits. Many pines rely on wildfires to melt open their resinous cones and release their seeds.

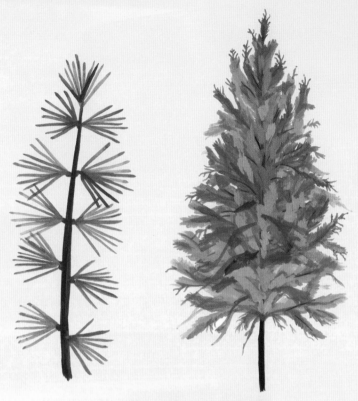

LARCHES

Larch trees (genus *Larix*) are all deciduous; the needles, borne in tufty little clusters, turn yellow in autumn before falling off. When the female cones are young, they are red to bright pink and have the charming nickname of "larch noses." The northernmost tree on Earth is likely a Dahurian larch (*Larix gmelinii*) in Siberia. And the oldest known surviving wooden sculpture is made of larch. Called the Shigir Idol, it was found partially preserved in a Russian peat bog in 1890 and its age is an estimated 12,000 years. Archaeologists aren't sure of its purpose—suggestions include that it could have been a marker to warn rival hunter-gatherers to stay away or a religious item related to a creation myth. Depending on the way the broken pieces of the sculpture are reconfigured, it is anywhere from 9 to 17 feet (3 to 5 m) tall. Wooden objects are not often spared decay; most ancient wooden artifacts are long since lost to the ages. So while the idol is unique now, it may have been one of a sea of similar sculptures.

Shigir Idol

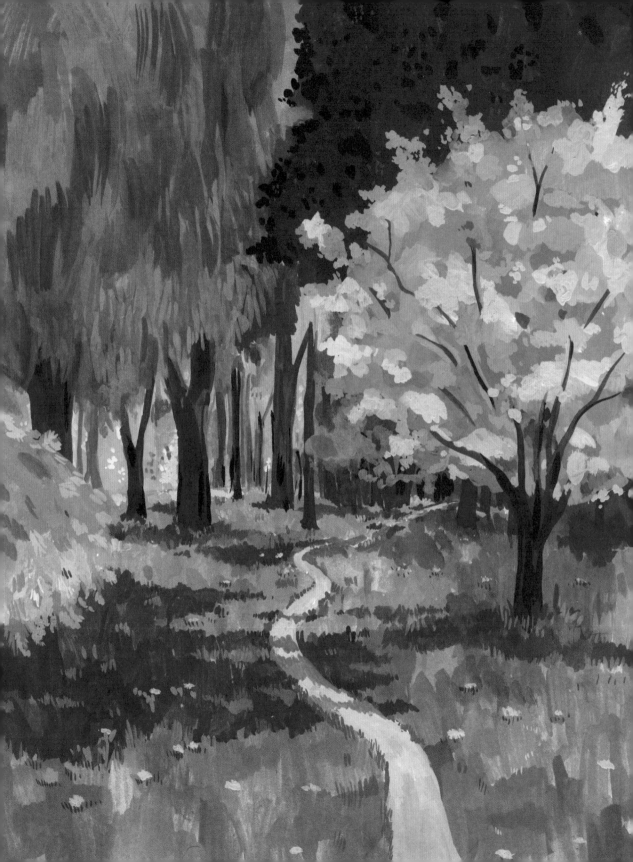

RESOURCES & MORE

RESOURCES

The World Encyclopedia of Trees, by Tony Russell with Catherine Cutler and Martin Walters, and *The Oxford Encyclopedia of Trees of the World*, from Bayard Hora, are extensive encyclopedias covering as many different types of trees from around the world as you could hope for. If you live in North America, *The Sibley Guide to Trees*, by David Allen Sibley, is equally comprehensive and operates as a field guide, leading you through the identification of more than six hundred native and introduced species. The *Peterson First Guide to Trees of North America* is another beautifully illustrated resource. Any number of pocket guides exist for tree identification, and I suggest researching one specific to your area—I was able to find a *Trees of Minnesota* field guide for use in my own backyard.

Tree websites abound as well. The Arbor Day Foundation's site (arborday.org) has a friendly interface for step-by-step identification particularly suited to beginners. For a treasure trove of passionate writing on trees and forests, as well as related plant subjects, head to the United Kingdom's Kew Gardens website (kew.org)—a little exploration there will lead you toward specialized field guides, too.

OBSERVING TREES

In this book, we've encountered some of the most interesting trees on the planet. But discovering even the tree species right outside your door is like a ready-made, three-dimensional scavenger hunt. With a local or regional tree guide in hand, you can head to the nearest woods or even to the nearest tree-lined street, boulevard, or park to see what kind of trees are in your area. Working through the identification of a tree that you can see in person is a joy all on its own. You might try keeping a running list of all the tree varieties you encounter, or even drawing simple maps of the trees nearest to your home. For me, this exercise has transformed what was once an ambient background visual (pleasant enough) to a vibrant tapestry of characters.

Because even trees of the same species can vary based on their location, age, and surroundings, identification can sometimes prove puzzling. My recommendation in these cases is to embrace the unknown—correctly identifying a tree is exciting, but exhausting all possible avenues and still not being sure what exactly you're looking at can be meaningful, too. Simply observing the plant life around you with no aim of botanical identification is meaningful, too. We can center our observation in personal experience: How does this smell *to me*? What other trees does this individual one remind me of? Nature is so diverse; it just never runs out of ways to surprise and confound us.

CHAMPION TREES

The National Register of Champion Trees is a searchable online database of the largest trees in the United States. You can search by species or common name to find the biggest trees in any state—and even nominate for inclusion in the registry a big tree you know. You can also try searching online for information about the largest and oldest trees in your town. Many are even marked with monuments or included in local registries and can be visited.

One champion tree in my city, nicknamed the Ancient Oak, was once estimated to be 700 years old and was a touchstone in its neighborhood. It was a bur oak (*Quercus macrocarpa*), turned hollow over time, large enough to stand inside of, with an opening like a skylight to the blue sky above. In 2010, it was found to be dead and was condemned to be removed. When it was finally cut down and its rings counted, it was found to be only 333 years old, less than half its estimated age, but so much older than any person alive. A tall stump was left behind, still hollow, still open to walk inside of—a large, solid ghost shrine to a beloved living thing.

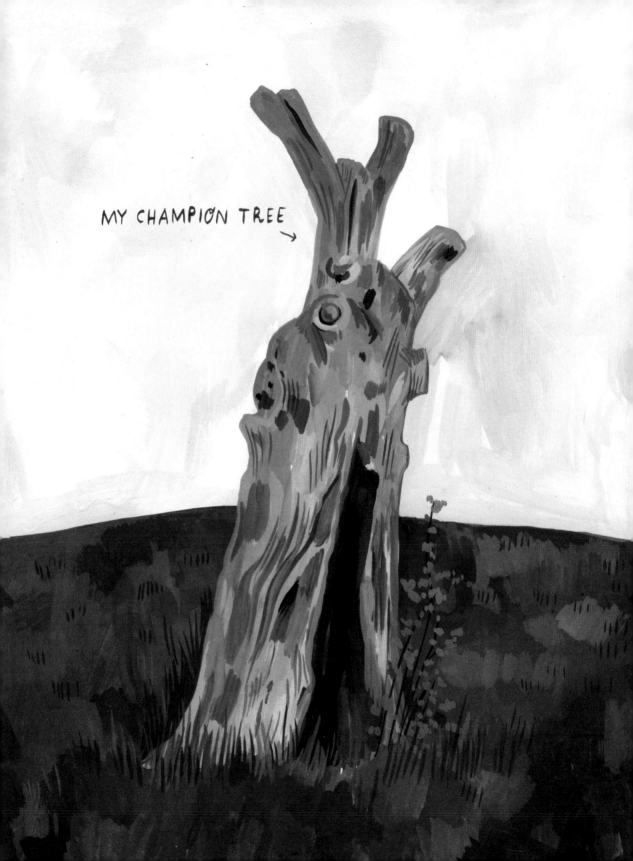

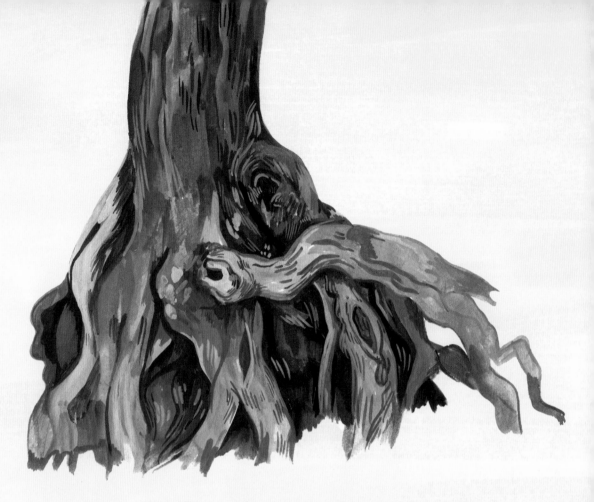

ACKNOWLEDGMENTS

Thanks are due to the Indigenous peoples of the world for stewarding the land and its trees, past and present. Thanks also to the archaeologists, historians, and w who have discovered, rescued, and preserved ancient wooden artifacts and unearthed truths about how humans and our ancestors have lived with and within trees. And thanks to all stewards of the land who are working to protect and celebrate what remains.

In particular, I would like to thank John and Mike Kosowski for refusing to cut down the blue spruce in our front yard. Also to Sarah Claasen, Julie Benda, Nicole Sarry, Ashley Pierce, Betsy Stromberg, and especially Kaitlin Ketchum for their help in making this book what it is. And my mom, for dragging us to every state and national park and forest she could find. And finally, to Mr. Little Guy, who lived in a tree, for his gracious correspondence.

ABOUT THE AUTHOR

Kelsey Oseid is an illustrator, writer, and amateur naturalist. She lives in Minnesota with her husband and young son.

INDEX

Typeface: The Northern Block's Halcom by Jonathan Hill

Library of Congress Cataloging-in-Publication Data

Names: Oseid, Kelsey, author.
Title: Trees : an illustrated celebration / Kelsey Oseid.
Description: First edition. | New York : Ten Speed Press, [2023] | Includes
 index. | Summary: "Discover the wonder of trees-one of the most essential
 life forms on the planet-in this beautifully illustrated, entertaining, and
 educational guide from the acclaimed author of What We See in the Stars"—
 Provided by publisher.
Identifiers: LCCN 2022032468 (print) | LCCN 2022032469 (ebook) |
 ISBN 9781984859419 (hardcover) | ISBN 9781984859426 (ebook)
Subjects: LCSH: Trees.
Classification: LCC QK475 .O84 2022 (print) | LCC QK475 (ebook) |
 DDC 582.16—dc23/eng/20220721
LC record available at https://lccn.loc.gov/2022032468
LC ebook record available at https://lccn.loc.gov/2022032469

Hardcover ISBN: 978-1-9848-5941-9
eBook ISBN: 978-1-9848-5942-6

Printed in China

Acquiring editor: Kaitlin Ketchum | Production editor: Ashley Pierce
Designers: Nicole Sarry and Betsy Stromberg
Production manager: Jane Chinn
Copyeditor: Kristi Hein | Proofreader: Lisa Brousseau
Indexer: Amy Hall
Publicist: Natalie Yera | Marketer: Chloe Aryeh

10 9 8 7 6 5 4 3 2 1

First Edition